IMAGES
of Rail

READING
TRAINS AND TROLLEYS

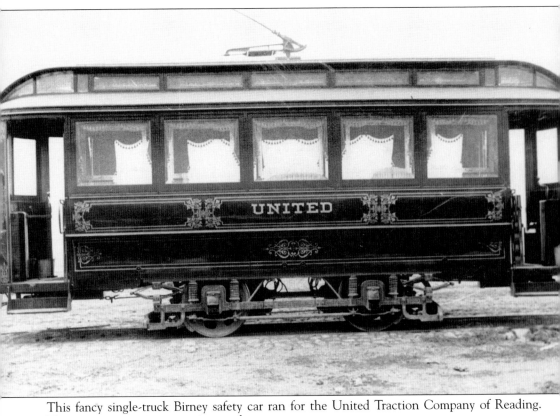

This fancy single-truck Birney safety car ran for the United Traction Company of Reading. Those ornate curtains are a nice touch.

IMAGES
of Rail

READING
TRAINS AND TROLLEYS

Philip K. Smith with
the Historical Society of Berks County

ARCADIA
PUBLISHING

Published by Arcadia Publishing
Charleston SC, Chicago IL, Portsmouth NH, San Francisco CA

Printed in the United States of America

Library of Congress Catalog Card Number: 2003116185

For all general information contact Arcadia Publishing at:
Telephone 843-853-2070
Fax 843-853-0044
E-mail sales@arcadiapublishing.com
For customer service and orders:
Toll-Free 1-888-313-2665

Visit us on the Internet at www.arcadiapublishing.com

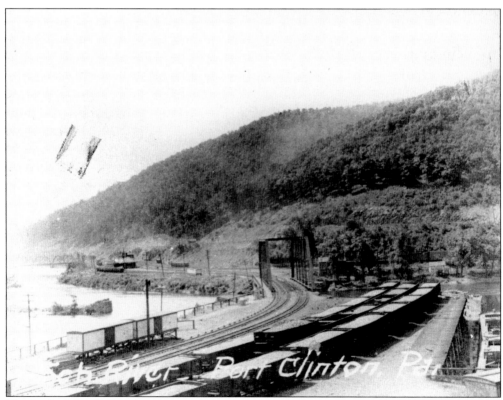

The Little Schuylkill Railroad passes loading docks of the Schuylkill Canal and meets the main line of the P&R at Port Clinton. This photograph dates from the late 19th century.

CONTENTS

ACKNOWLEDGMENTS

Delivering copies of *Baseball in Reading*, by Charles J. Adams III, a man from Arcadia Publishing said to Harold Yoder, executive director of the Historical Society of Berks County (HSBC), "Do you have any railroad photographs? Books of railroad pictures are popular." Yoder threw that idea to Adams, who tossed it to me. I contacted Kaia Motter of Arcadia Publishing, who guided us through the steps necessary to publish this history. Each of us stepped up to the plate and got a hit.

We are deeply grateful to members and friends of HSBC who have donated and preserved more than 15,000 photographs during the past 50 years. They bear witness to the vital role that transportation has played in Reading's history.

INTRODUCTION

Long ago, a large fishing village occupied the foot of today's Penn Street. Nearby was a natural ford that provided a great fishing spot. The Tulpehocken Path crossed that ford on its way from Philadelphia to Shamokin, through the Endless Mountains to the Iroquois stronghold in New York. Conrad Weiser lived by that path at Womelsdorf and used it for 30 years in negotiations with the Iroquois and the Lenape until his death in 1760. Chief Menangy of the Schuylkill clan of the Lenape had used the adjacent Perkiomen Path to attend treaty conferences with William Penn in Perkasie in 1683. Such accessibility attracted land speculators and a few early settlers. They prompted William Penn's son Thomas to locate Reading "on a piece of land" in a "very good Situation," as he wrote to his brother John in 1739.

The next transportation milestones were the Schuylkill Canal (1825) and the Union Canal (1827). Constructed to keep the Erie Canal from enriching New York Harbor at the expense of Philadelphia, they linked Reading with Pottsville, Philadelphia, and Middletown-Harrisburg. Canals achieved remarkable efficiency. One or two horses (or mules) could haul 35 tons in a single boat, far beyond the capacity of any other form of land transportation. Both canals were rebuilt for greater capacity, and the Schuylkill Canal could eventually accommodate 200-ton boats. The speed was four miles per hour—walking speed—as it had always been for land transportation. But the Philadelphia & Reading Railway (P&R) was built to do better than that.

Chartered on April 4, 1833, the P&R was constructed for steam locomotives. The first were imported from England. Then, American manufacture started. When the P&R was completed to Philadelphia (1838) and extended to Pottsville (1841), trips between those cities took a few hours instead of a few days. Shops that repaired those locomotives began to build them. Freight cars and passenger cars were maintained and built in shops of their own. Progress made headlines in Reading and beyond. Crossing Pennsylvania by a series of canals, railroads, and inclined planes required a week. Completion of Horse Shoe Curve and a troublesome tunnel at Gallitzin (1854) provided an all-rail route and cut that time to 24 hours. The Golden Spike linked Omaha, Nebraska, and Sacramento, California, 15 years later. An all-rail route across America enabled trains to cross the whole country in 10 days, then in 5 days. Reading, railroads, and America grew up together.

By the 1860s, Reading had a population of 30,000. Street railways were proposed for transportation to downtown stores, factories throughout the city, and recreational areas. In 1865, the Reading City Passenger Railway Company was incorporated but wilted from lack of support. In 1873, two companies were incorporated almost simultaneously: a new Reading City Passenger Railway Company (RCPRC) and a Penn Street Passenger Railway Company. Both began construction and scheduled completion in 1874. The RCPRC laid track on Sixth Street from Canal Street to Robeson and Charles Evans Cemetery. The RCPRC also held the rights for the Penn Street line that operated from Front Street to 11th Street and then down Perkiomen Avenue to 19th Street. That line did not earn a profit, so it was sold to the Perkiomen Avenue Passenger Railway Company in 1881. As Reading's population grew, both companies expanded as demand for transportation increased. By 1885, 36 cars and 112 horses served most of the city. In Richmond, Virginia, a new transportation era was dawning.

Born in Connecticut in 1857, Frank J. Sprague was a mathematics whiz at age 16 and graduated with high honors from Annapolis Naval Academy at 21. After his first cruise, at the naval torpedo station in Newport, Rhode Island, his thoughts turned to electric transportation. Leo Daft, Charles J. Van Depoele, and Thomas Edison had made progress. Sprague's great innovation placed two motors in one truck in "wheel-barrow fashion." Each motor was supported by an axle and by a spring mount on the truck frame. His motors could safely bounce over bumps and keep sturdy, simple drive gears engaged. The Richmond Union Passenger Railway attracted worldwide attention to his designs, and they soon spread to trolley lines throughout America. In 1886, such trolleys were running in Reading. The last horsecar ran on Cotton Street on June 29, 1894.

Faster, larger, cleaner, and more efficient than horsecars, trolleys brought public transportation to the far reaches of Berks County, to communities not served by big steam railroads. By 1904, passengers could ride connecting lines to Philadelphia. At their peak in 1914, lines extended to Womelsdorf, Mohnton, Kutztown, Boyertown, and the Oley Valley.

By 1947, trolleys were rapidly being replaced by buses. The last trolley in Berks County ran between Reading and Mohnton on January 7, 1952.

Reading bus routes are operated by Berks Area Reading Transportation Authority (BARTA), publicly owned since 1973. Service has been extended to Womelsdorf and to Cabela's on a hill above the Hamburg Cloverleaf (Routes 61 and I-78).

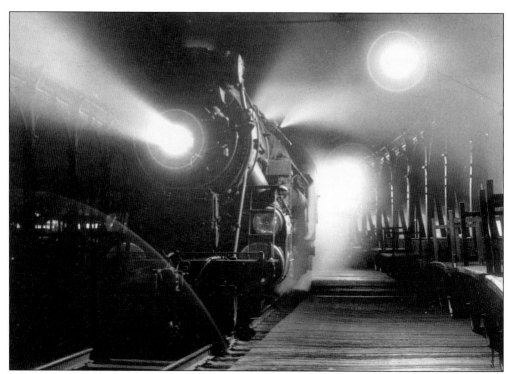

In a poignant scene, Jersey Central 4-6-2 No. 832 pauses at the Outer Station. Ornate supports for the train shed are illuminated by a light and by the headlight beam. No. 832 still has silver cylinder covers from fast passenger service on the *Blue Comet* between Jersey City and Atlantic City, but those days are gone. Passing years will consign No. 832, its train, and the Outer Station to history. Yet in this photograph we see them once more. We hope that the photographs in this book will bring back memories and inspire admiration and respect for those who have come and gone before us.

One

PEOPLE

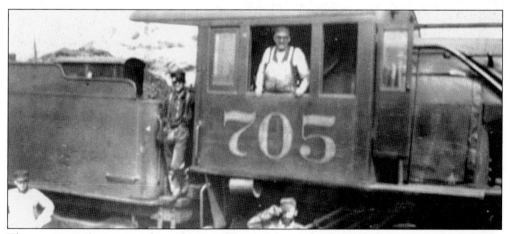

The engineer, fireman, and conductor of Long John end cab 2-8-0 (two pilot wheels, eight driving wheels, and no trailing wheels) No. 705 pose for the camera. That was a big locomotive back then.

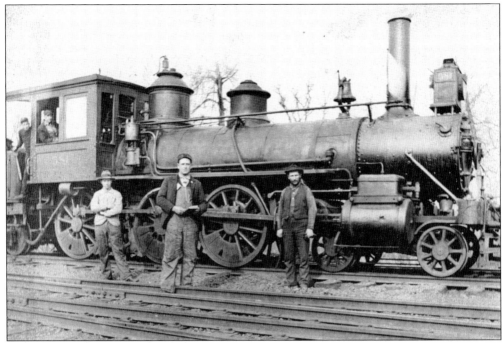

This photographer must have been a railfan, for the crew of this narrow-firebox 4-6-0 is carefully positioned to reveal mechanical details. Locomotives like this were acquired as the Philadelphia & Reading leased independent lines and merged them into the system.

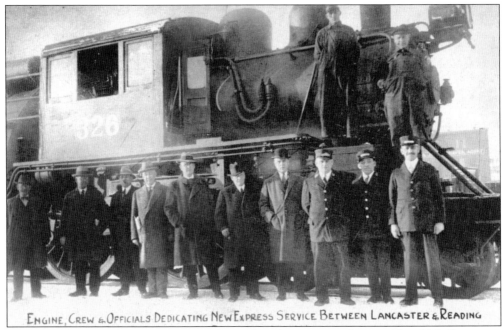

ENGINE, CREW & OFFICIALS DEDICATING NEW EXPRESS SERVICE BETWEEN LANCASTER & READING

Express service between Lancaster and Reading began on February 23, 1926. Departing Lancaster, that hefty camelback will roll along the Reading & Columbia Branch to Sinking Spring and then follow the Lebanon Valley Branch to the Outer Station.

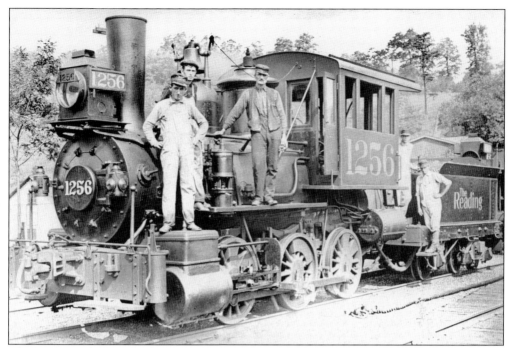

This crew stands upon loading dock locomotive No. 1256 at Port Clinton in the early 1900s. The Little Schuylkill Navigation, Railroad & Coal Company connected the Schuylkill Canal at Port Clinton with coal fields and businesses at Tamaqua. In 1841, it met the main line of the P&R (from Pottsville to Philadelphia). Today, it links the Reading, Blue Mountain & Northern (RBM&N) with Scranton and New England. Home of RBM&N offices and shops, Port Clinton has been a transportation center for nearly 180 years.

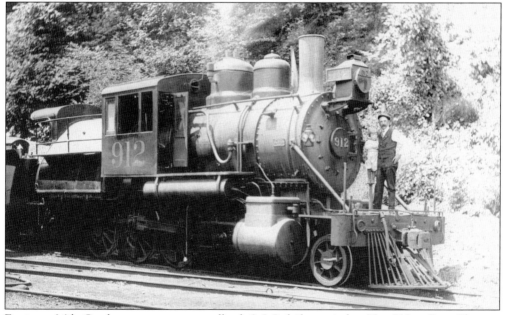

Engineer Milt Gordon poses upon camelback 2-8-0 shifter-switcher No. 912 at Port Clinton. How rail traffic has grown there!

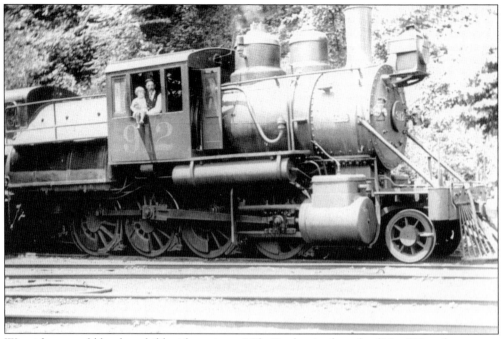

We wish we could be that child with engineer Milt Gordon in the cab of No. 912 under steam.

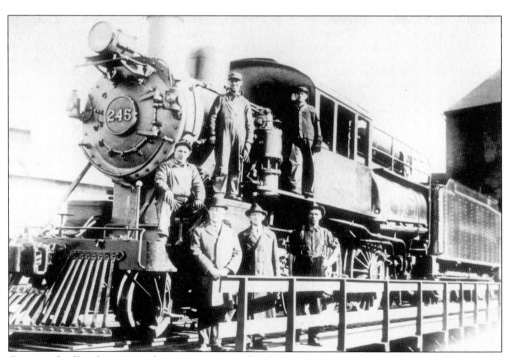

Crew and officials pose with passenger camelback No. 245 on a turntable, probably on the Reading & Columbia Branch, in the 1920s. Imagine shoveling coal from the tender into that wide Wootten firebox as a train rolled along, mile after mile.

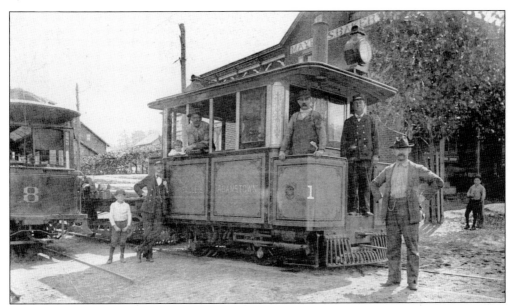

The boy is Parker Miller. Nathan P. Zweizig is the engineer. Charles Bossler is the conductor. Steam dummy No. 1 of the Mohnsville & Adamstown poses with the crew and citizens at Mohnsville (Mohnton) in September 1894. Like Toby the Tram Engine, friend of Thomas the Tank Engine, No. 1 has a covered running gear for a neat, trim appearance.

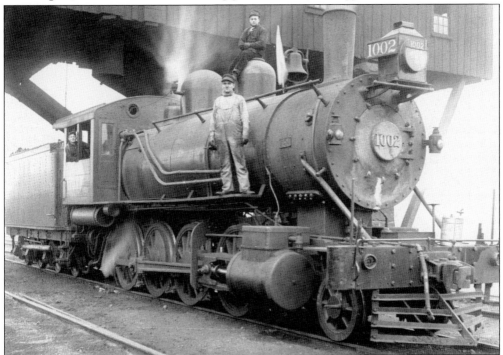

Brakeman (atop the sand dome), fireman, and engineer of Long John narrow firebox 2-8-0 No. 1002 are ready for the road. Locomotives like this ran on the Schuylkill & Lehigh (also known as the Slatington Branch). Part of this line is operated by the Wanamaker, Kempton & Southern. For years, the *Berksy* carried students to and from high school in Slatington.

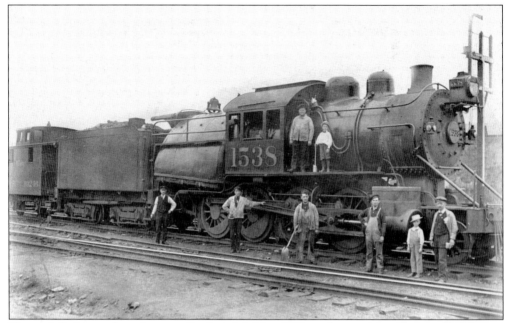

These skilled men brought camelback 2-8-0 No. 1538 and train No. 52 from Reading to Allentown. The engineer is Charles E. Heckman; the conductor is John J. Sanders; the fireman is Charles W. Fisher; the brakemen are John H. Stroh and Frank E. Haas; the flagman is Maylon Y. Fister. That little boy is in good company. Note the little four-wheel wooden bobber caboose.

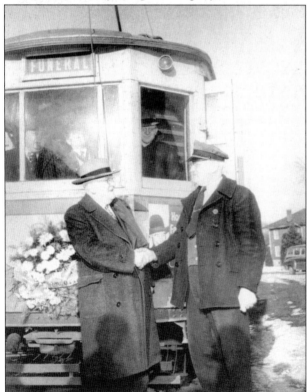

J. P. Costello, superintendent of the Reading Street Railway Company, congratulates operator Edwin R. Brunner upon 50 years of service with the company. Car No. 807 ended trolley service in Berks County, running between Reading and Mohnton, on January 7, 1952.

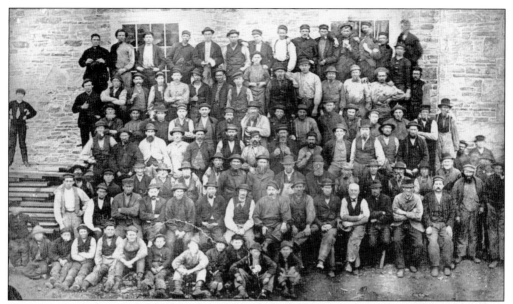

Here we see workmen of the original P&R shops at Seventh and Chestnut Streets in the late 1800s. From 1902 to 1904, locomotive and car shops were relocated north of the Outer Station between Sixth Street and Eighth Street, near George Field.

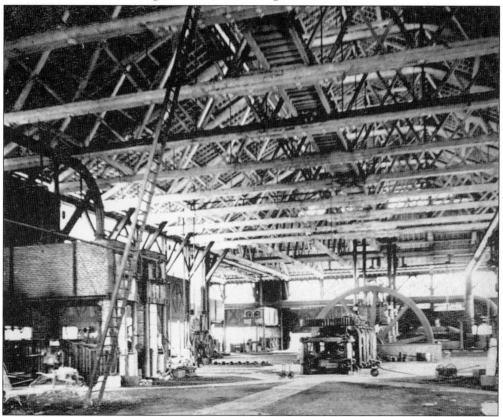

This rare photograph offers an interior view of the shops at Seventh and Chestnut.

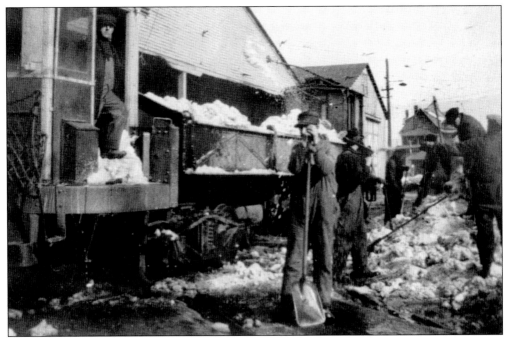

With no place to put snow on a busy city street, a self-propelled freight motor was pulled up, snow was shoveled into it, and the snow was hauled away. Those low sides fall flat as the bed tilts, dumping snow in a few seconds. Toy train operators have enjoyed dump cars for years. Today, cities use dump trucks instead of trolleys.

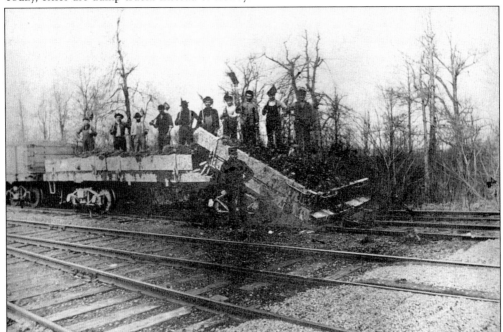

This looks like a wrecked car, but it is a ballast car, a variation of a dump car. The end tilts down to place ballast directly on the ties, where it is needed. Today, for greater capacity, hopper cars are used, modified to dump ballast slowly on the ties.

Two

MOTIVE POWER

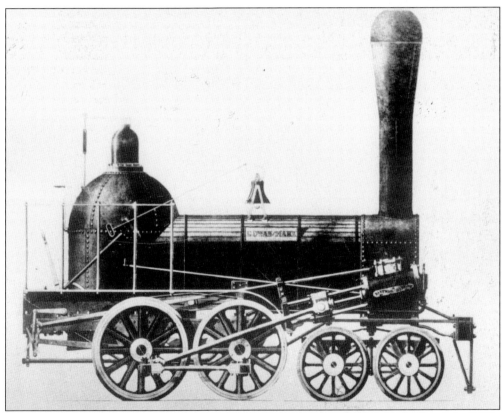

Named after the London banking partnership that financed the Little Schuylkill and the P&R, the *Gowen & Marx* in 1840 pulled 104 loaded coal cars—40 times its own weight—for 54 miles from Reading to Philadelphia at an average speed of 9.82 miles per hour. So impressed was Czar Nicholas of Russia that he persuaded the builders of that amazing locomotive (Eastwick and Harrison) to relocate from Philadelphia to St. Petersburg, where they stayed for 10 years helping to construct the first railway in Russia.

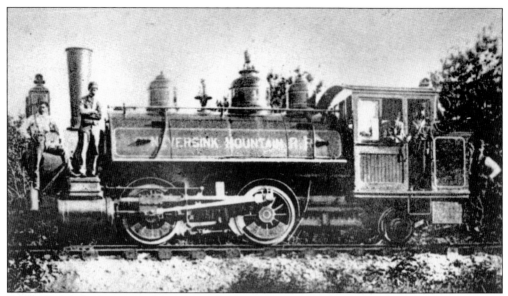

Opened on July 31, 1890, the Neversink Mountain Railroad was the first in America to use hydroelectric power. However, demand exceeded supply, so 25-ton 0-4-2Ts like this were leased from the P&R until sufficient power was available.

For 40 years, the P&R struggled to devise a firebox that would make steam quickly with hard, slow-burning anthracite. This wooden model, 49 inches long and 14 inches high, reflects a design by James Millholland, master of machinery at the Reading Shops (from 1848 to 1866). His firebox is underneath the cab. Coal is shoveled in the rear. It resembles Ross Winans's camel locomotives purchased by the P&R. Camel No. 217 is preserved in the B&O Railroad Museum at Pratt and Poppleton Streets in Baltimore.

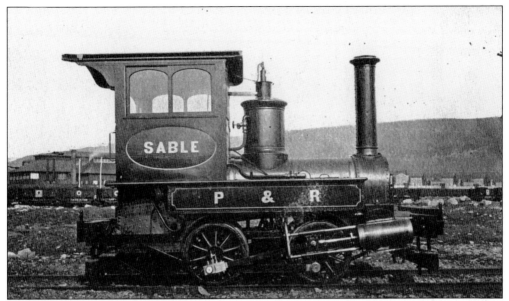

The *Sable* is another Millholland locomotive, a shifter-switcher designed for light rails and tight curves. It was one of 11 built by the P&R between 1867 and 1872.

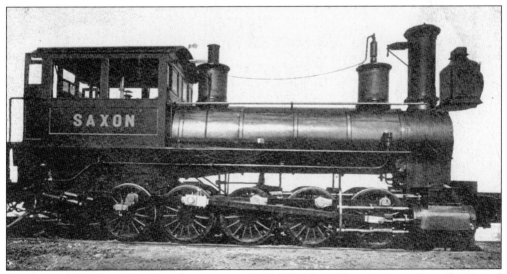

The *Saxon* (1868) was the first of seven giant 0-10-0 "push-up" locomotives. A tender carried coal and water. The *Saxon* served the P&R for 15 years, ending its career around Shamokin.

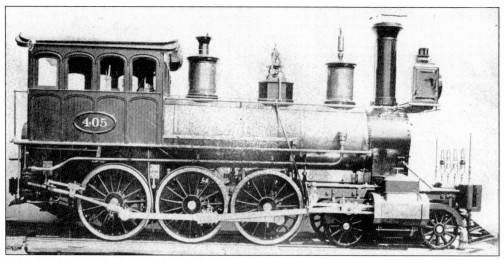

No. 405 is one of 20 improved Millholland "gunboats," initially named after Civil War gunboats or battle locations, constructed from 1873 to 1877. The rod at the rear driver operates a water pump. The engine had to be moved to pump water into its boiler.

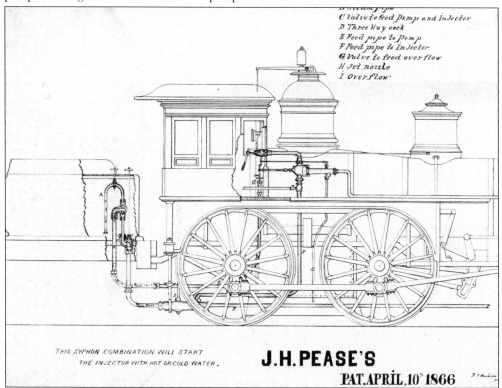

C *Valve to feed Pump and Injector*
D *Three Way cock*
E *Feed pipe to Pump*
F *Feed pipe to Injector*
G *Valve to feed over flow*
H *Jet nozzle*
I *Overflow*

THIS SYPHON COMBINATION WILL START THE INJECTOR WITH HOT OR COLD WATER.

J. H. PEASE'S

PAT. APRIL. 10ᵗ 1866

J. H. Pease's patent (April 10, 1866) illustrates an injector, a quantum leap in technology. A valve in the cab allows steam at boiler pressure to surge through a nozzle and mix with water from a tender or from a tank on a locomotive. The steam condenses, but its rapid flow forces water through a check valve into the boiler. That seems as implausible as a perpetual-motion machine. But it works, and boilers have been equipped with injectors ever since. It also works while a locomotive is standing still.

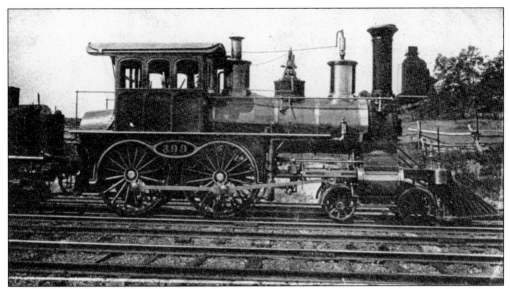

No. 399 is one fancy gunboat built by the P&R in 1874. It seems to sport brass boiler bands and pinstriping on its running board, drivers, and driving-wheel fenders. We shall see other fancy Reading locomotives, too.

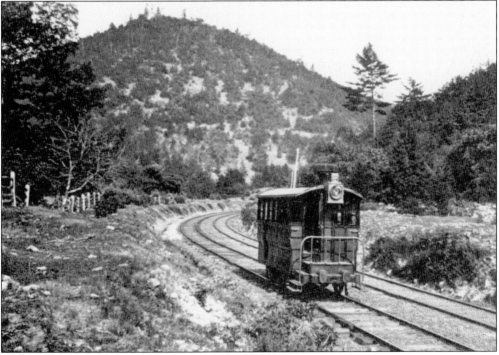

The P&R had nine little inspection engines like this. Company officers, managers, and road foremen used them to inspect the road and construction projects. Paymasters used them to roll up to section gangs and repair crews and pay wages on the spot. The engines consisted of compact car bodies atop small steam locomotives. We hope this is the *Black Diamond*, because that little gem rests in the St. Louis Museum of Transportation. A caption places this photograph on the Mine Hill & Schuylkill Haven.

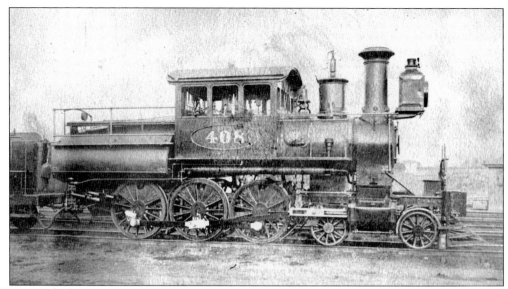

In 1867, John E. Wootten succeeded James Millholland as master mechanic and devoted himself to perfecting a firebox that would burn culm—waste anthracite piled up throughout the coal regions. Ten years later, he came up with a wide firebox and grate for a light, thin fire and carefully controlled draft that spread heat evenly. He also devised a feedwater heater.

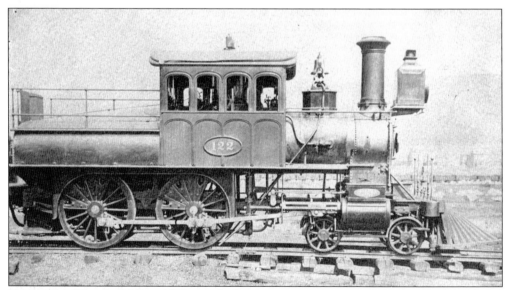

No. 122, built by the P&R in 1878, is a sleek passenger engine. Its straight, level running board accentuates its wide Wootten firebox tucked above the rear drivers. There is some mighty fine woodwork in the cab.

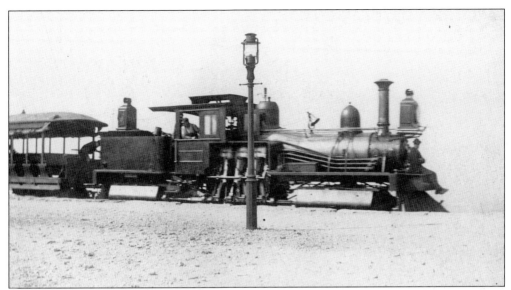

This is a two-truck Shay of the Mount Penn Gravity Railroad. Three vertical cylinders in front of the cab turn a line shaft. Universal joints transmit power to a bevel gear on each axle. A Shay can handle light rails, rough track, and tight curves of logging and mining railroads. This Shay muscles passenger cars up Mount Penn, where they descend by gravity. The best place to experience Shays in their natural environment is the Cass Scenic Railroad at Cass, West Virginia, in Seneca State Forest, an easy day's drive from Reading.

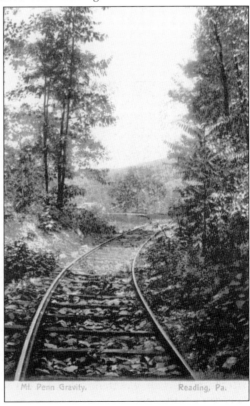

The Mount Penn Gravity Railroad was well suited for a Shay.

Passengers are getting a fast ride behind that Pennsylvania Railroad Class D 4-4-0. The 80-inch drivers are a blur.

This is a closer look at a swift Class D. Those high drivers lift the boiler and cab above the tender.

A P&R passenger train cants on a superelevated curve. Like curves on racetracks, this curve tilts inward to allow higher speeds.

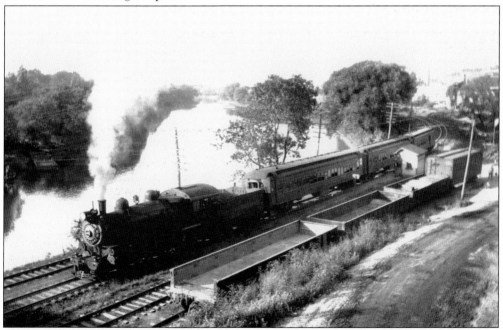

A Pennsylvania Railroad Class E-5 4-4-2 runs between the Schuylkill Avenue Bridge and Parish Steel, opposite 999 River Road. Note the little depot. A larger station is located at the foot of Penn Street. The Schuylkill Valley Division connects Broad Street Station in Philadelphia with Reading, Pottsville, and Wilkes-Barre. That little iron horse can easily top 70 miles per hour with twice as many cars. Here, *Seabiscuit* is trotting.

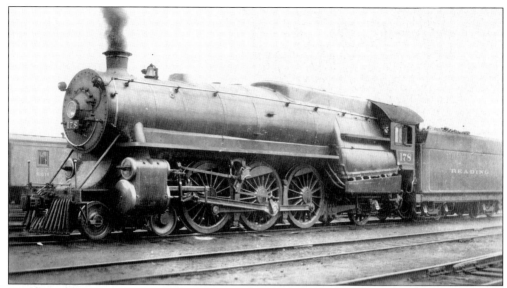

Seen here is a fancy locomotive—No. 178, one of five beefy G-2 4-6-2s built by Baldwin in 1926. In 1934, an older, smaller G-lsa (No.108) received a semistreamlined facelift, and No. 178 was given similar treatment in 1936. Air brake pumps were concealed in the water legs of their tenders. In 1937, G-1sa Pacifics No. 117 and No. 118 were outshopped with streamlined shrouds to match new stainless-steel *Crusader* passenger cars.

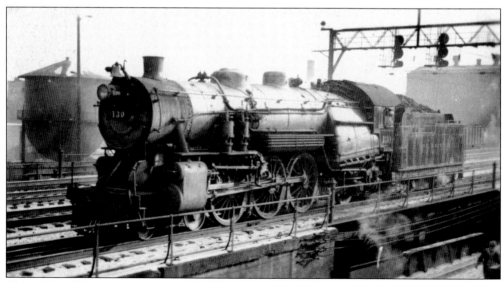

G-1sa No. 130 presents a picture of latent speed at Green Street Engine Terminal in Philadelphia. Nos. 108, 178, 117, and 118 looked like this before their makeovers.

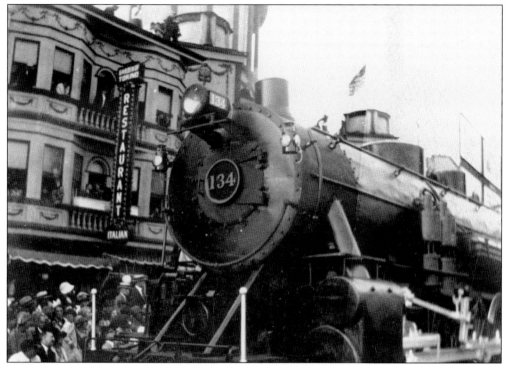

In 1924, Baldwin completed an order for five Reading 4-6-2s, Nos. 130 through 134. Later that year, a full-sized replica of No. 134, constructed almost entirely of wood, was placed on the boardwalk at Atlantic City for a Miss America pageant. Could this be that replica?

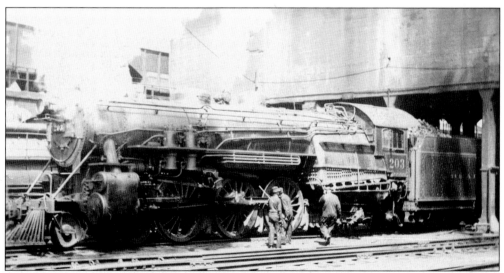

No. 203 is one of five G-1sb Pacifics built by Baldwin in 1925 with 74-inch drivers (instead of 80-inch ones) for service on the Bethlehem Branch and on the main line, where its smaller drivers provided more power at slower speeds.

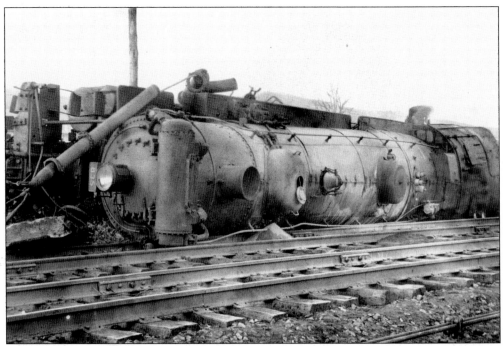

Around suppertime on January 26, 1934, the eastbound *Harrisburg Special* hit an automobile at a grade crossing in front of the Blandon Hotel. No. 835 derailed and turned over, trapping the engineer and fireman and scalding them to death. Five of the seven cars derailed but remained upright. No passengers were hurt, despite flying china and silverware in the diner.

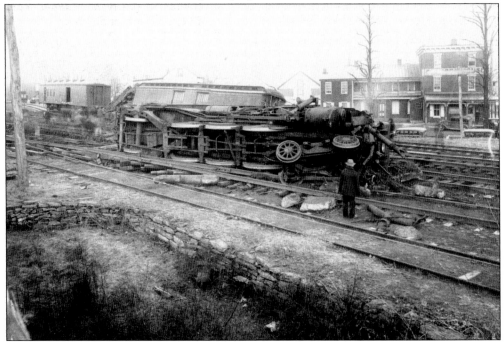

No. 835 was a sister of *Blue Comet* locomotives that ran between Jersey City Terminal and Atlantic City.

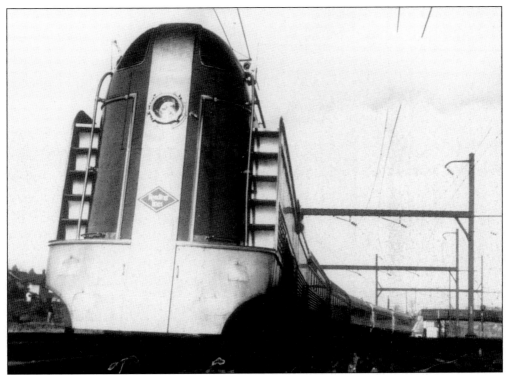

This is a publicity shot of the *Crusader* "clad in shining armor," the first streamlined train in the East (1937). The five-car stainless-steel train was built by Budd in Philadelphia. To avoid turning the train at Jersey City Terminal and Reading Terminal, an observation car was placed at each end. One is displayed in the Railroad Museum of Pennsylvania at Strasburg.

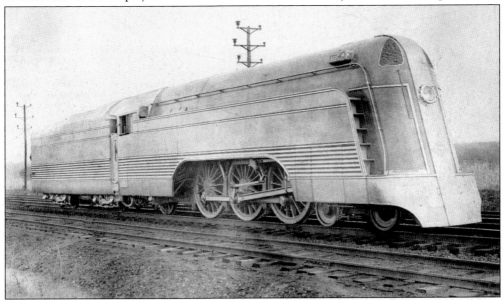

The *Crusader*'s drivers were painted (probably blue) when this photograph was taken. Notice the electropneumatic brakes on the pilot wheels. Both locomotives and all five cars had these state-of-the-art brakes for smooth, quiet stops.

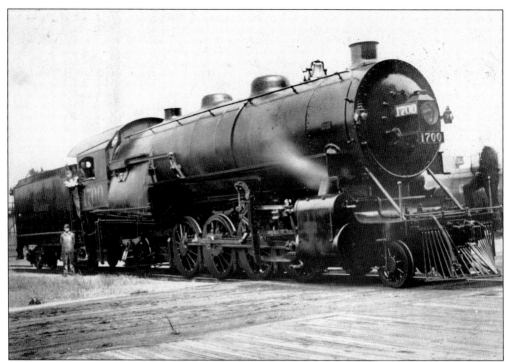

Experimental 2-8-2 No. 1700, built by the Reading Shops in 1912, had the first Wootten firebox with a rear cab and a stoker (Duplex D-1). A trailing truck (Hodges) was the first for a Reading freight engine, too. Baldwin constructed 56 more (from 1913 to 1917). All had two pilot wheels, eight driving wheels, and two trailing wheels.

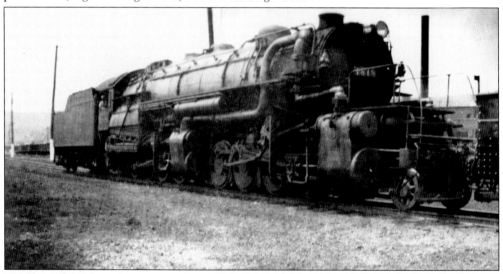

The Reading's largest locomotives were 30 2-8-8-2 Mallets. No. 1818 was built by Baldwin in 1918. They used steam twice, first in both rear cylinders and then in larger front cylinders. Like a truck in low gear, they were powerful but limited to 25 miles per hour. Eleven were rebuilt as huge K-1 2-10-2s. The rest were upgraded during the 1930s and late 1940s. No. 1818 has four "simple" cylinders, increasing its speed and power. But all Reading Mallets and even the mighty K-1s were scrapped by 1955.

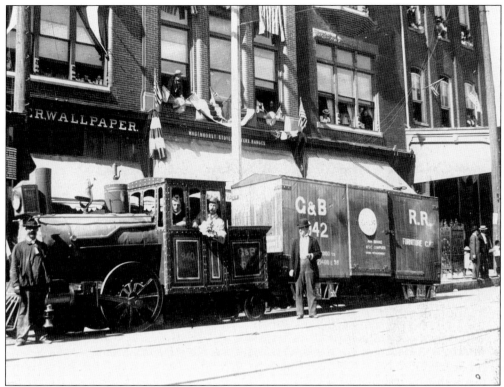

This parade float was photographed on Penn Street, between 9th and 10th, in 1898. A lot of work went into the float.

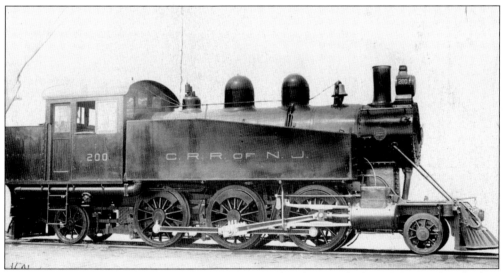

This Central Railroad of New Jersey engine resembles the parade float. The Reading had 10 counterparts, Class Q Suburban engines. Built for commuter service, they ran well in either direction. Compact and powerful, they became obsolete when Philadelphia routes were electrified, and all were scrapped by 1936, during the Great Depression.

Rebuilt in the Reading Shops during the late 1940s, No. 201 resembles a T-1 4-8-4 and a G-3 4-6-2. By that time, the Reading was already buying diesels. Formerly the handsome *Blue Engine*, painted regal dark blue with yellow striping and a Reading Lines "black diamond" herald on the tender, No. 201 was a memory by 1953.

The Reading had 126 0-6-0 shifters-switchers, end cabs, and camelbacks. They were used everywhere. The only survivor is 0-6-0T shop switcher No. 1251 in the Railroad Museum of Pennsylvania at Strasburg. Fortunately, a Jersey Central 0-6-0 like this one is the subject of Restoration Project 113 at the Reading's Minersville depot. Camelback 4-4-2 No. 592 at the B&O Railroad Museum in Baltimore is the only other Jersey Central steam locomotive left.

Three

YARDS, SHOPS, AND ENGINE HOUSES

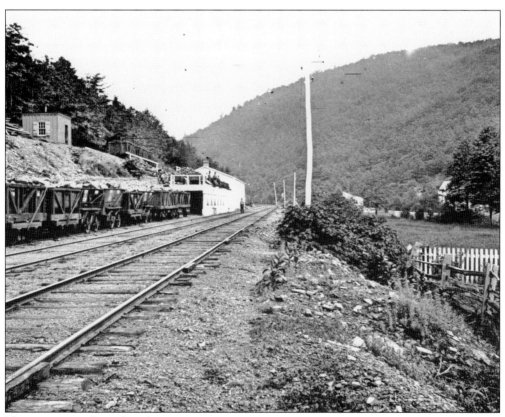

Here we see tracks and coal jimmies.

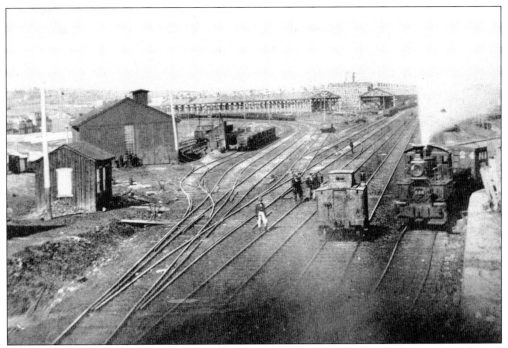

The Walnut Street yard looked like this during construction of the Outer Station in 1874.

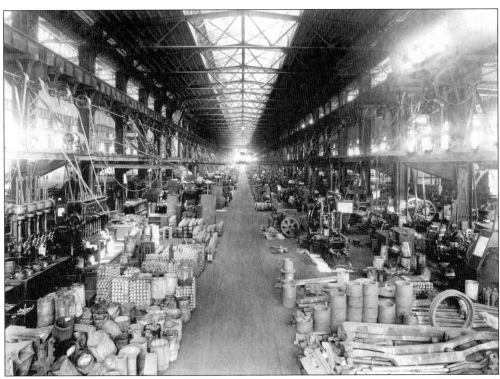

This is the interior of the new (1902–1904) machine shop. Every piece is electrically operated. This building along North Sixth Street is 880 feet long and 335 feet wide.

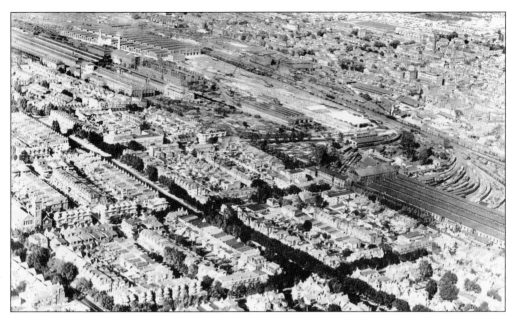

This is an aerial view of the Reading locomotive shop and car shop, flanked by Sixth and Ninth Streets.

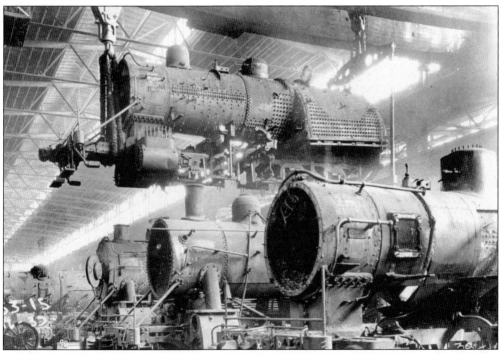

A boiler, cylinders, and a frame fly through the locomotive shop, held by an overhead crane. "The Progressive System of Repairing Locomotives," imported from the B&O by Charlie Gill in 1933, was actually a revival of a system devised by James Millholland in the old Reading Shops at Seventh and Chestnut Streets in the 1850s. A shop was divided into sections, and locomotives were moved from section to section as work progressed. In 1910, Henry Ford perfected that system to mass-produce Model Ts.

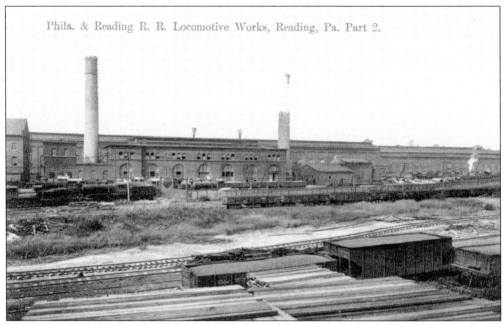

The Reading locomotive shop is seen here.

Freight cars and passenger cars were built and repaired in the car shops, east of the locomotive shop near Eighth and Ninth Streets.

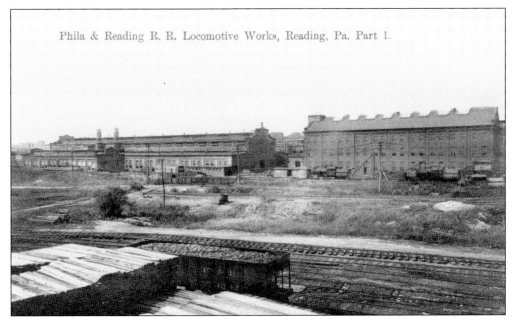

The locomotive shop built 627 steam locomotives and rebuilt hundreds more.

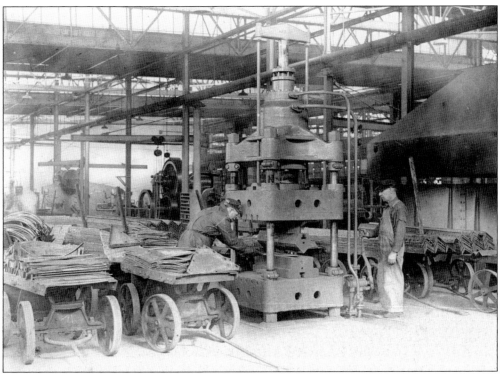

These are craftsmen of the car shops.

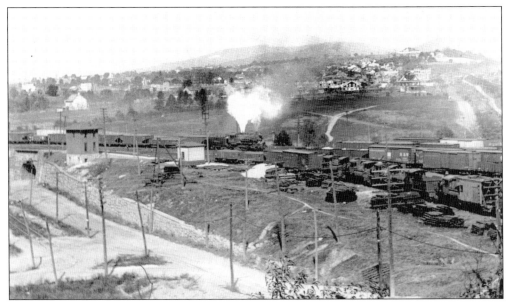

This is the northern approach to the Reading yard, the Reading Shops, and the Outer Station, east of George Field. North Sixth Street meets Heister's Lane at that stone underpass.

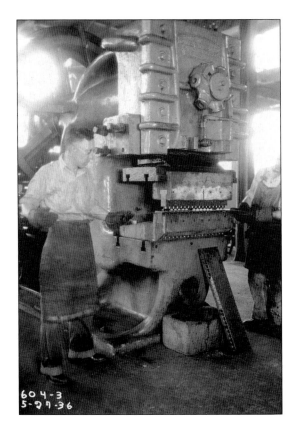

These men are stamping brass passenger car parts. Note the finished product propped up on the floor between them.

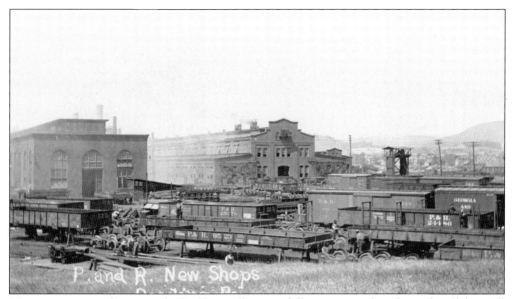

Many repairs were done outside. Railfans will notice different types of trucks, and modelers will concentrate on different cars and lettering.

Here we see passenger car trim, Reading style.

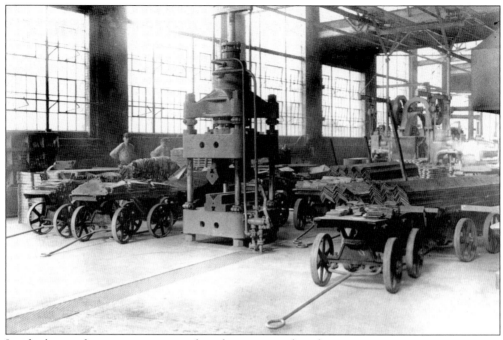

Inside the car shop, wagons, material, and a press stand ready.

Big parts require big machine tools.

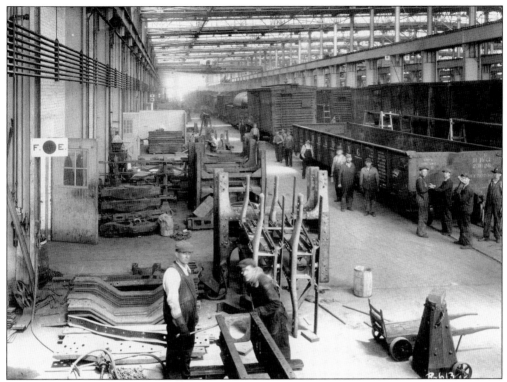

Various freight cars occupy Bays 7 and 8 inside the car shop.

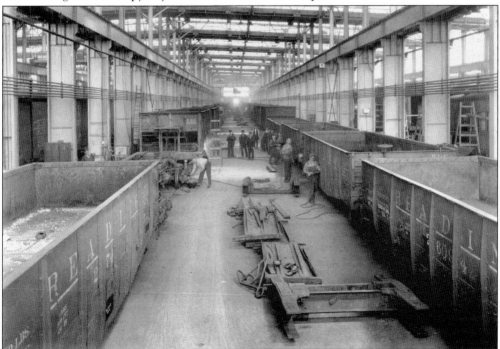

In Bays 3 and 4 of the car shop, 55-ton-capacity steel hopper cars are being repaired and trucked—having trucks installed.

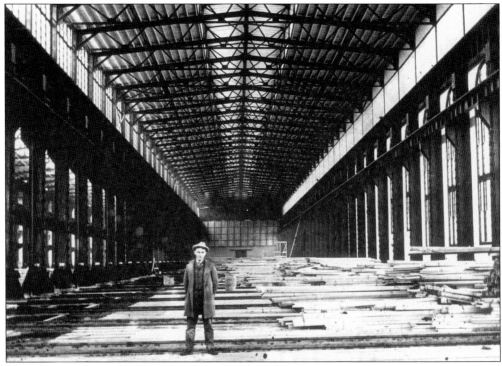

This photograph vividly illustrates the scale of Reading locomotive shop.

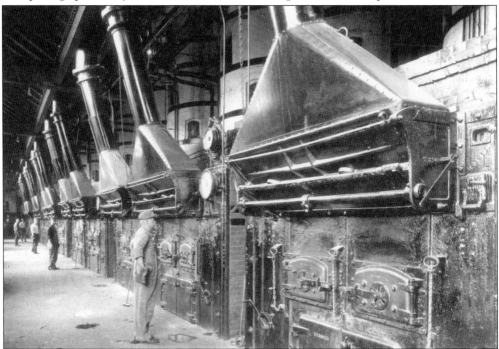

A long row of huge boilers supplies steam to the Reading Shops, the roundhouse, the Outer Station, and connections that provide steam heat to warm up waiting passenger cars before a locomotive couples on. This is the interior of the powerhouse.

Parts used in the Reading Shops came from this storehouse, located along Spring Street near the Spring Street subway.

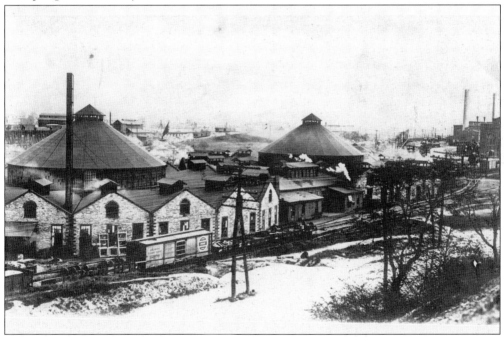

These Civil War–era stone roundhouses stand north of the Reading Shops, near George Field. Both will be replaced by one modern semicircular roundhouse in 1919, but for now they seem as majestic and permanent as the pyramids. Their design recalls the B&O's Mount Clare car shop and passenger car roundhouse, now the main building of the B&O Railroad Museum in Baltimore.

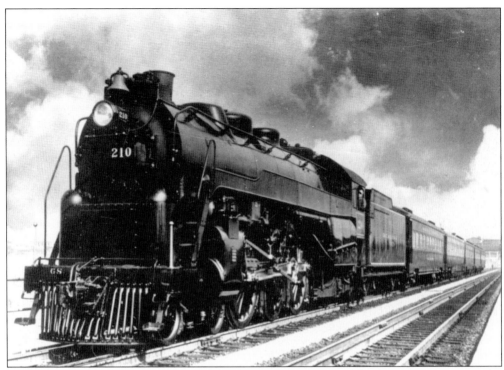

Brand-new G-3 Pacific No. 210 poses with new 2000-series turtleback passenger cars on the Lebanon Valley Bridge, opened in 1947. The Reading Shops built nine more G-3s. These cars attracted passengers. Steam still ruled the Reading in 1947.

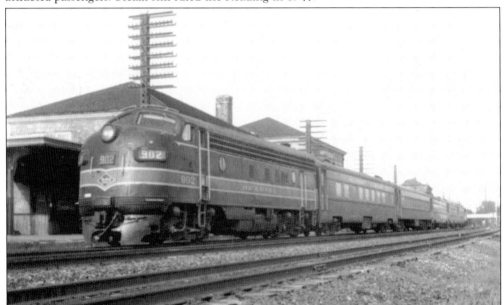

By 1957, steam was a memory. In 1965, northeastern railroads began a dismal slump that led to Conrail in 1976. One bright spot was this "push-pull" train. It had an FP7A at each end, four 2000-series cars, and one standard coach (1547, the last on the Reading). Seen at Pottstown, this train ran between Reading and Philadelphia until 1981, when passenger service to Reading ended.

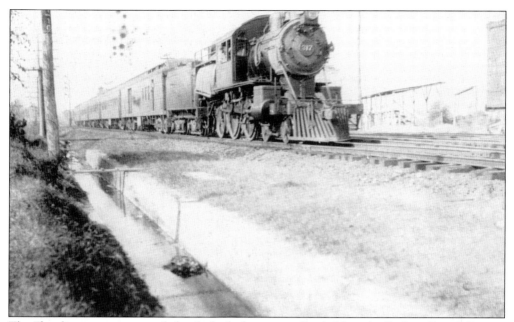

The *Flyer* lives up to its name behind a high-driver camelback. Note the Railway Post Office car behind the tender. Postal clerks sorted, sent, and delivered mail until 1963, when mail contracts were signed with trucking companies and airlines.

Couplers and drawbars await repairs and installation in the car shop.

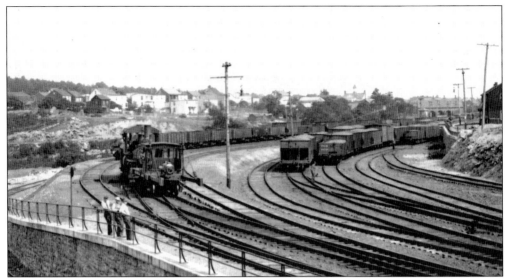

On July 16, 1912, an official P&R photographer took this picture of the modernized Frackville yard at the top of Mahanoy Plane. Loaded coal cars (right) rolled by gravity from the plane headhouse (out of view) after gigantic stationary steam engines had hoisted them out of Mahanoy Valley, 21 miles north of Pottsville. On the left is a poling car. An operator extended poles from each side to move cars on adjacent tracks. (Courtesy the Reading Company Technical and Historical Society; Reading Company photograph.)

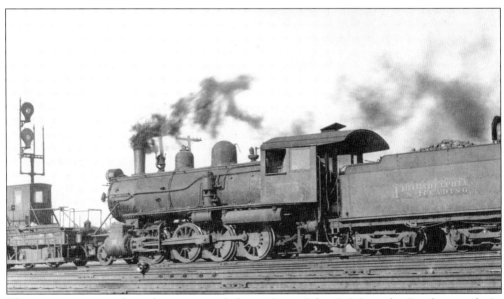

This is a rear view of a poling car coupled to a Long John 2-8-0 in the Reading yard. As locomotives and cars became larger and heavier, poles were prone to cracking and breaking. The practice was replaced by building a hump, pushing a string of cars up one side, uncoupling them, and letting them roll down to the proper track by gravity. Rutherford became a hump yard.

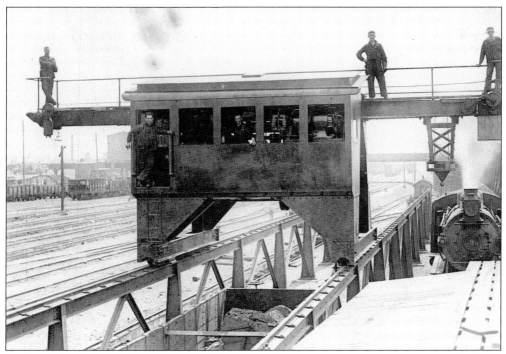

Coal-burning steam locomotives produce ashes. Ashes accumulate in ash pans beneath fireboxes. Ash pans are dumped into ash pits between the rails. Here, a traveling clamshell digs the ashes out and dumps them in gondolas or hoppers to be hauled away. In these rare photographs, we see this clamshell in action, beginning with the crew.

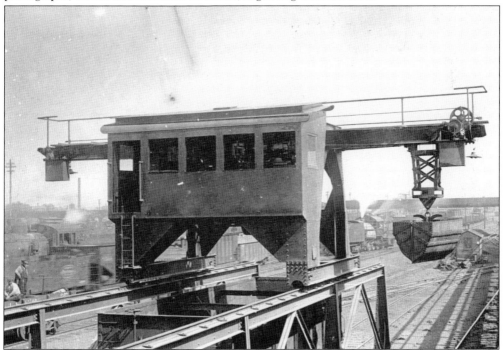

Now the clamshell is in place.

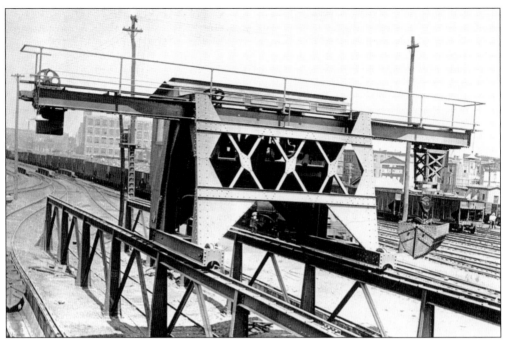

This is a rear view of the clamshell.

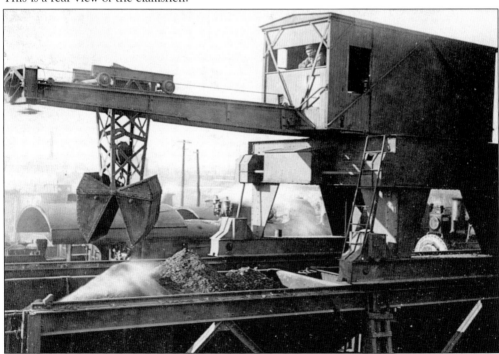

The ashes are dumped into hopper cars or gondola cars and hauled away. One photographer, amid steam engines panting and hissing in a busy engine terminal, stepped onto what he thought was solid ground between the rails. It was a thin crust over an ash pit filled with water. He was instantly submerged up to his shoulders. Fortunately, he quickly lifted his camera over his head. His camera and film were spared, but not his shoes, pants, and shirt.

Four

STATIONS

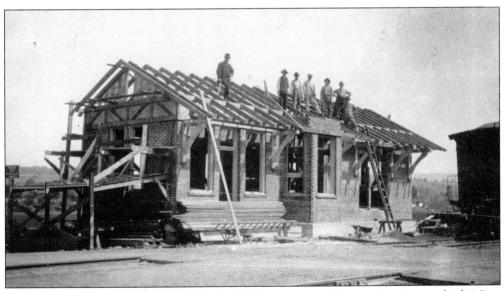

In 1914, workmen are building an 18- by 50-foot station at Bern, soon given a final "e" to distinguish it from post offices with similar names. Railway Post Office cars serve the post office in Natftzinger's (later Kline's) general store a half-mile west in Berne. The author's grandfather Clarence B. "Geed" Kline was postmaster in the 1950s.

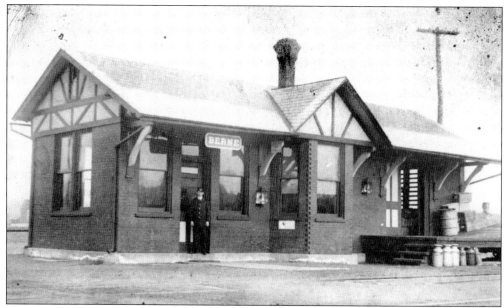

Ticket agent George C. Kershner (1889–1966) stands by the door to the waiting room. He served until this station closed in 1929. Some 20 years later, Max Hubacher visited friends and was surprised to find a village named after his native city in Switzerland. Employed by Kodak in Rochester, New York, he gave his glass-plate negatives of scenes in the area to Miriam Smith, who donated them to the Historical Society of Berks County.

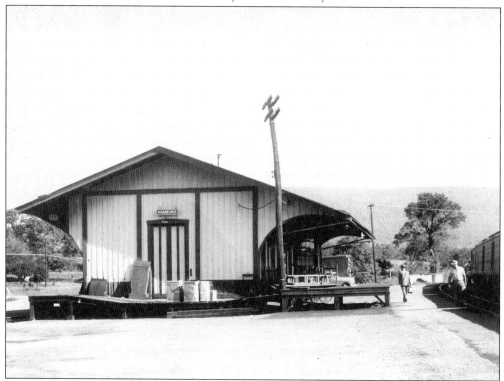

This "umbrella" station in West Hamburg was built in 1877.

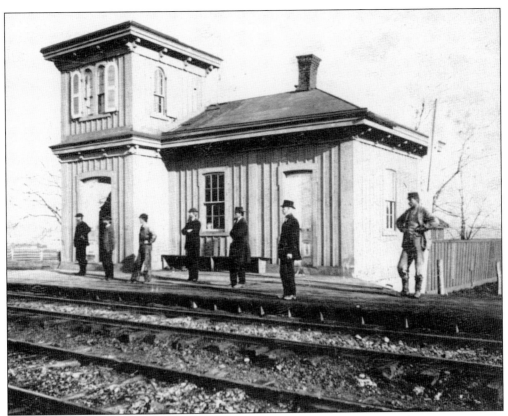

This is the Robesonia depot (built in 1856) on the Lebanon Valley Railroad.

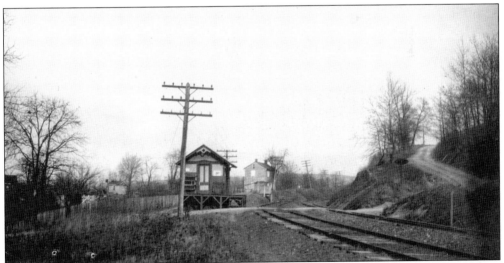

During the 1880s, P&R president Franklin B. Gowen constantly clashed with the Pennsylvania Railroad. So intense were hostilities that the Pennsylvania Railroad, at enormous expense, invaded the upstart's territory with a parallel line that ran from Broad Street Station by city hall in Philadelphia through Reading to Pottsville and then onward to Hazleton and Wilkes-Barre. This photograph was taken south of Leesport.

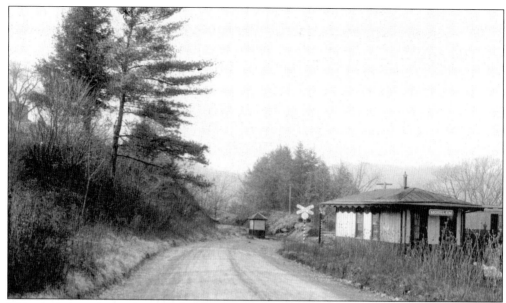

This charming scene is located along the Berks County Railroad, or Schuylkill & Lehigh, at Moselem, 13 miles northeast of Reading. The photograph was taken on November 25, 1932, and the road is Route 135, Rural Route 06124.

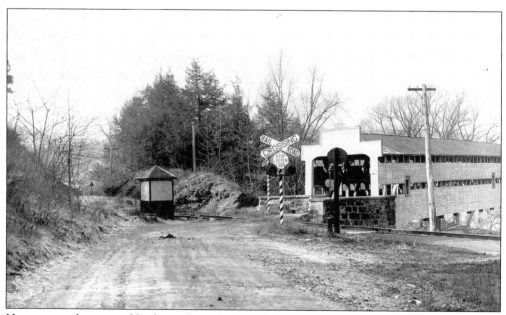

Here we see the covered bridge and watchman's shanty at Moselem. Watchmen walked to the middle of a crossing and warned drivers with red flags by day and lanterns by night. Many were Civil War veterans or employees injured on the job.

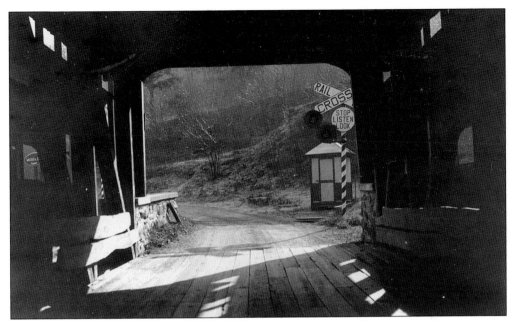

This is the watchman's shanty (watchbox) from inside the covered bridge.

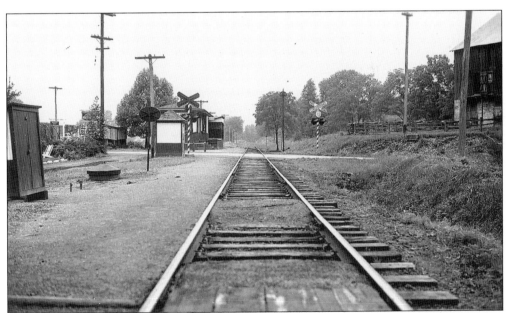

We are east of Lenhartsville, 30 miles northeast of Reading, where the Schuylkill & Lehigh Branch crosses Route 22 near Route 78 exit 35. The station was built in 1878. Notice all the details, including the tall switch lamp, elevated so engine crews can see it. The date is July 19, 1938. Today, the Wanamaker, Kempton & Southern runs five miles north, along Routes 143 and 737.

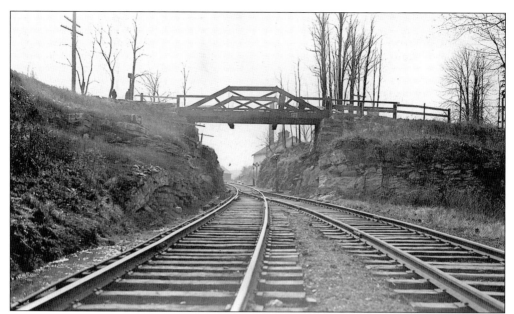

The Berks County Railroad curves underneath a P&R road bridge at Maiden Creek Dam.

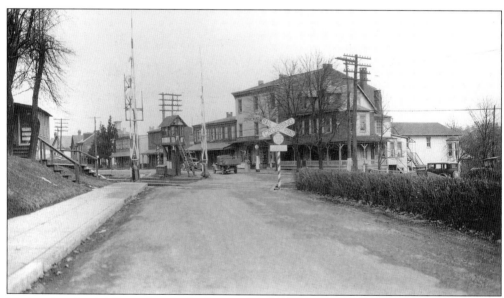

Notice the circular Stop, Listen, Look sign. During a grade crossing suit, Reading attorney Edward M. Paxson declared, "If you claim that 'Beware of the Engine & Cars' is insufficient warning—then I say that if the driver of the team would stop, look and listen—this case would never have come to court." The Reading soon adopted "stop, look, and listen" as a grade crossing warning, and so did railroads across America. (From back of Iron Horse Rambles album by RALBAR.)

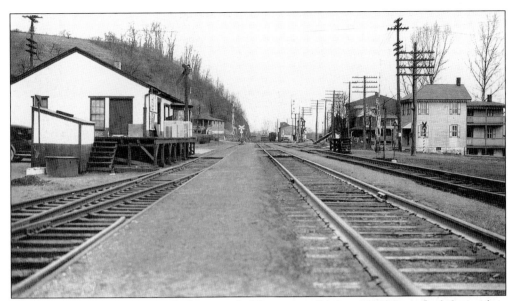

West Leesport is seen in a view looking north. The station (built *c.* 1877) is on the left. A siding extends between the station and the two-track main line. That is unusual, but heavy freight traffic requires it.

This view includes the station. The Reading also constructed a stockyard and a coal chute here.

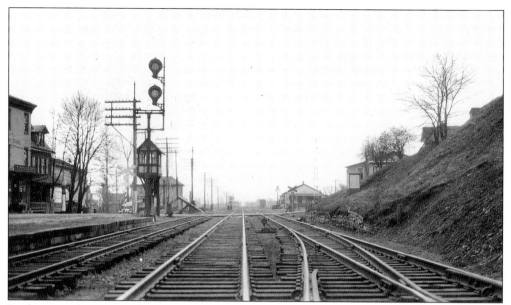

Looking south, we see the station on the right. Note the Hall, or "banjo," signals and an elevated crossing watchman's shanty.

In this view across the Schuylkill River in downtown Leesport, we see the Schuylkill Valley Division of the Pennsylvania Railroad. In the distance is smoke from a Reading train.

This photograph was taken in Orchard, just below Leesport, at Ontelaunee Orchard. The Schuylkill Valley Division of the Pennsylvania Railroad came through in 1884 in response to combative P&R president Franklin B. Gowen. A long siding left the P&R main line, crossed the Schuylkill River, and ran along the Pennsylvania Railroad. A tower was necessary to coordinate train movements, but there was no passenger station here. Such a clear photograph at such an obscure location is remarkable. A similar tower (J tower) stands by the Strasburg Rail Road station.

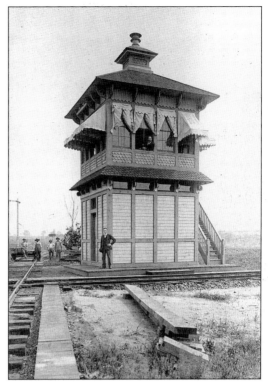

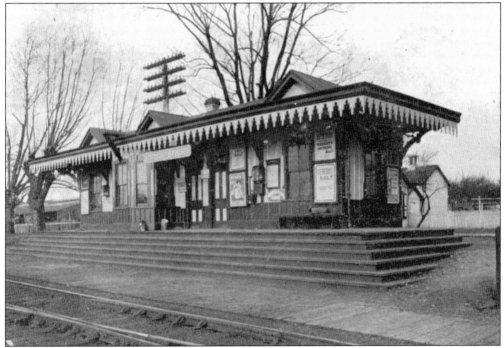

Mailed on April 30, 1907, this postcard shows the fancy P&R station at Sinking Spring (built in 1878), along the Lebanon Valley Branch. Thanks to local citizens, this station has survived. The Reading & Columbia Branch, still active, swings south here.

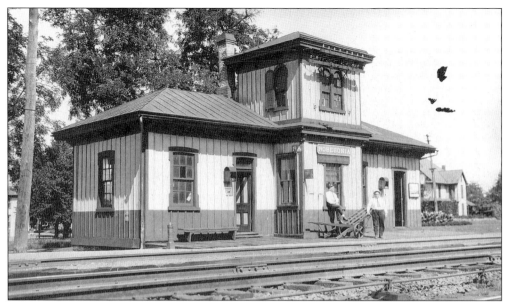

This station has moved. Built in 1856 at Robesonia along the Lebanon Valley Branch, it was enlarged in 1860 and rebuilt in 1882. In March 1957, three months after its retirement, Augustus Wildman purchased it and moved it to New Cumberland (near Harrisburg) for a model railroad clubhouse and a hobby shop.

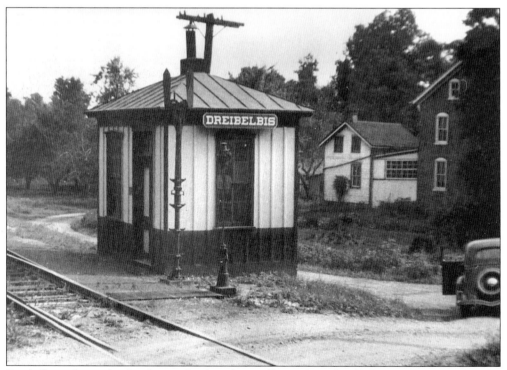

Dreibelbis is located 1.6 miles south of Lenhartsville on the Schuylkill & Lehigh Branch. The Dreibelbis covered bridge still stands near the right-of-way. This station was built in 1891.

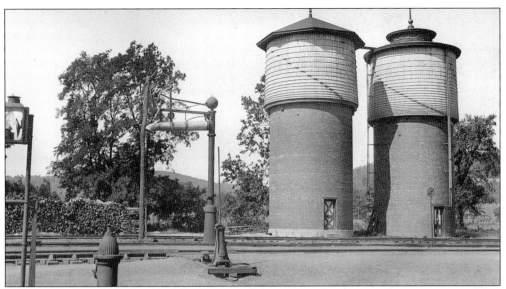

These water towers at Robesonia supplied standpipes, or plugs, for steam locomotive tenders. Their roofs differ. Wooden water tanks atop circular stone foundations were common on the P&R. Some foundations still stand.

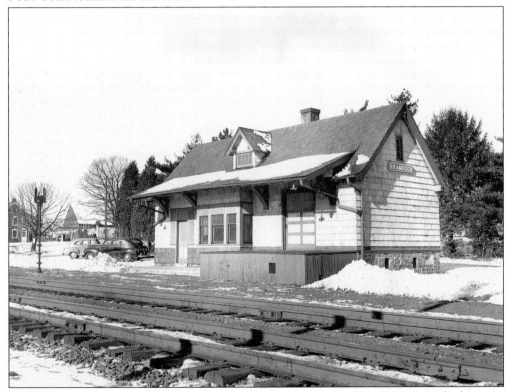

Shamrock was located 14.6 miles west of Allentown, on the East Penn Branch, between Alburtis and Mertztown. At first, a 14- by 14-foot room was rented from a local store and used only for freight service. A ticket agent arrived after a new station was constructed in 1899. It was remodeled as shown by 1915.

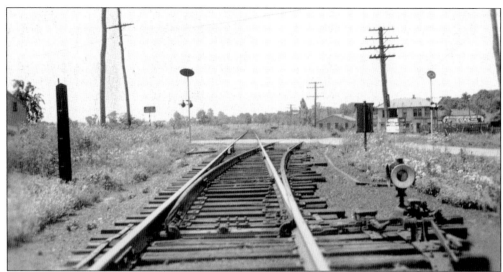

This bucolic scene abounds in details. That extra metal between the switch lamp and the track reveals that this switch was once controlled from an interlocking tower. Longer ties supported control rods. By 1936, during the Great Depression, the tower was gone, the siding was overgrown, and the switch was thrown manually. Note the coal sign.

Another scene nearby depicts a boxcar being unloaded. Someone is doing a bit of business. Beneath that tall shed are some coal bins, or pockets. A coal (hopper) car is spotted above them, and doors are opened under the car to unload the coal. Judging by those weeds, that has not happened lately.

The crossing sign was inspired by Reading attorney Edward M. Paxson (see page 54).

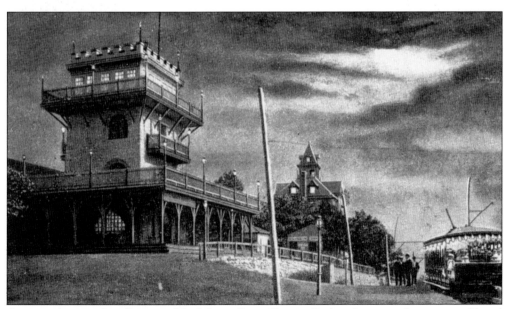

An open (summer) trolley car of the Mount Penn Gravity Railroad stops at the tower and hotel atop Mount Penn. Electricity has replaced the Shay (see page 23).

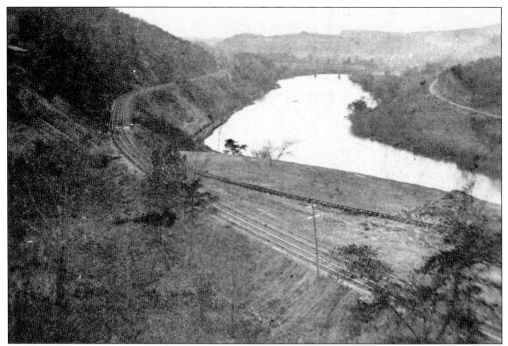

Klapperthal is the location of a sweeping curve on the bank of the Schuylkill River, of a junction with the Wilmington & Northern (later Belt Line Junction), and of various stops and attractions at the eastern end of the Neversink Mountain Railroad: Klapperthal Station, Pavilion, Park, Road, Glen, and Creek.

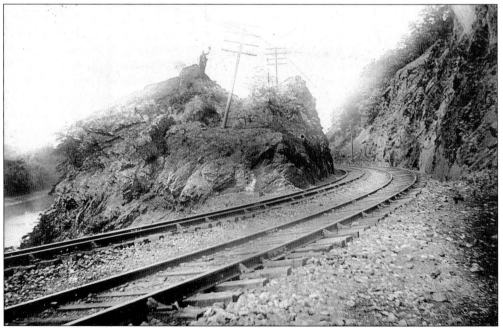

This cut testifies to the heavy rock work at Klapperthal. The P&R was the first railroad in America designed for steam locomotives, not for horses. Its surveyor and chief engineer, Moncure Robinson of Virginia, cut no corners.

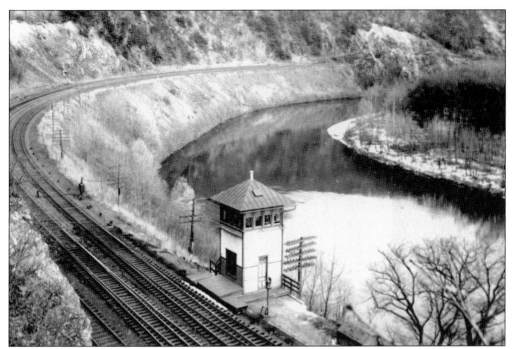

Three miles below Reading, Klapperthal was a prime location for taking photographs. Iron Horse Rambles had "Speed" picture stops here. Passengers got off, and the train backed up out of sight and then came charging forward, whistle blowing. Another famous train was the *Crusader* on a preinaugural system tour in 1937. In 1948, G-3 Pacifics headed semistreamlined 2000-series cars of the *King Coal* (Philadelphia to Shamokin), the *Schuylkill* (Philadelphia to Pottsville), and the *Wall Street* (Philadelphia to Jersey City) at this location for company photographs.

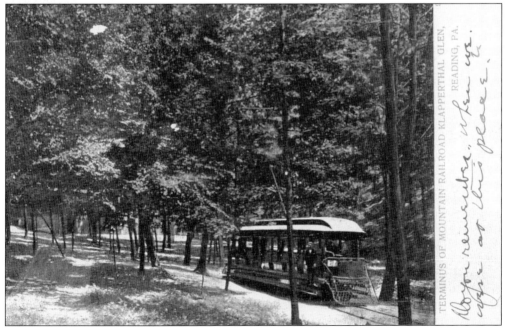

A Neversink Mountain Railroad trolley pauses at Klapperthan Glen, above the railroad.

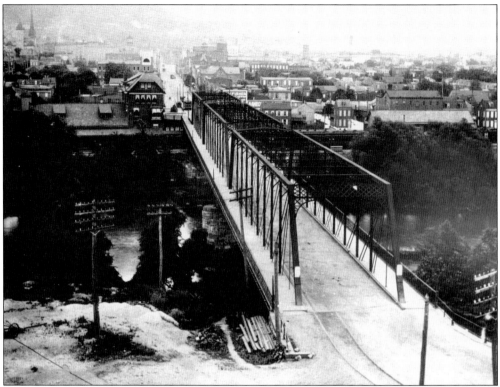

The Pennsylvania Railroad came through Reading by the east bank of the Schuylkill River. This is the station at Penn Street, at the eastern end of the Penn Street Bridge. Some track is still there today, and the right-of-way is used by Rails-to-Trails. Graceful concrete arch bridges west of Klapperthal are part of the Thun Trail.

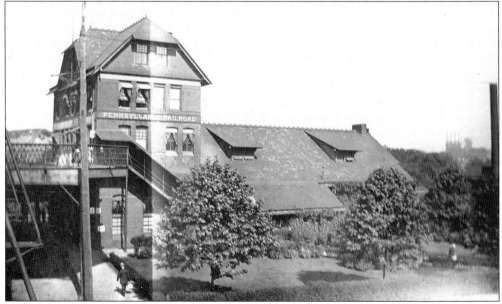

Here are the Pennsylvania Railroad station and Penn Street Bridge before 1912.

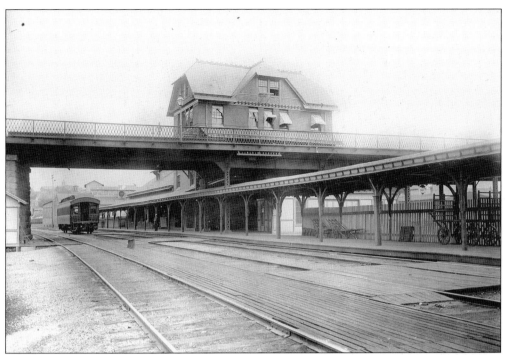

This is a closer view of the station, platform, a wooden coach, and even a train order board that signals an engineer and conductor to stop and pick up directions for train movements, or orders, written on thin sheets called flimsies.

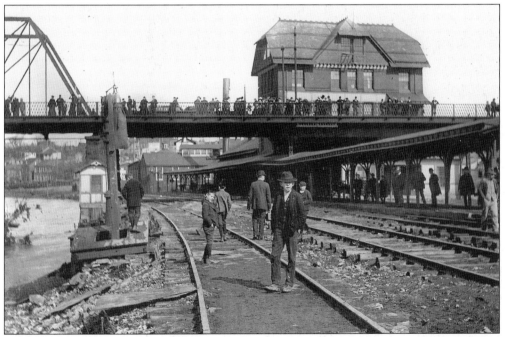

A crowd is gathering at the Pennsylvania Railroad station in Reading and on the Penn Street Bridge. This was an impressive station with a long train platform. It seems small in most photographs, but it was taller than the bridge.

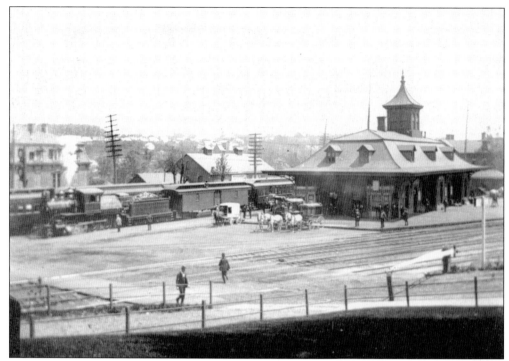

The Lehigh Valley and the Reading served this station in Bethlehem by the Hill to Hill Bridge. A connection with the Lehigh Valley's *Black Diamond* (New York City to Buffalo) used the Bethlehem Branch to Reading Terminal, Philadelphia, 56.6 miles southeast. The Jersey Central station (now the Main Street Depot) is below the northern end of the bridge at Main and Lehigh Streets. Fine food is served in a handsome station.

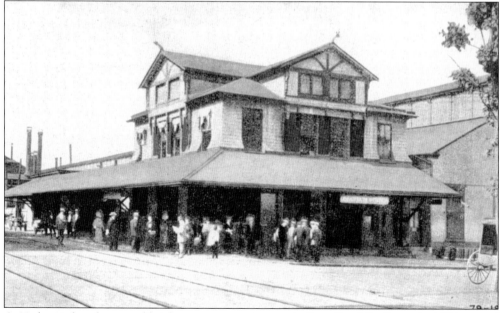

A 41- by 41-foot frame and brick passenger station was built at Franklin Street in 1884, one of the few peaceful achievements of P&R president Franklin B. Gowen.

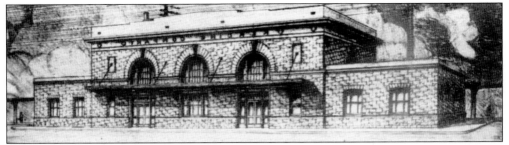

This is an elevation of the present Franklin Street Station, opened on February 25, 1930, south of the 1884 station.

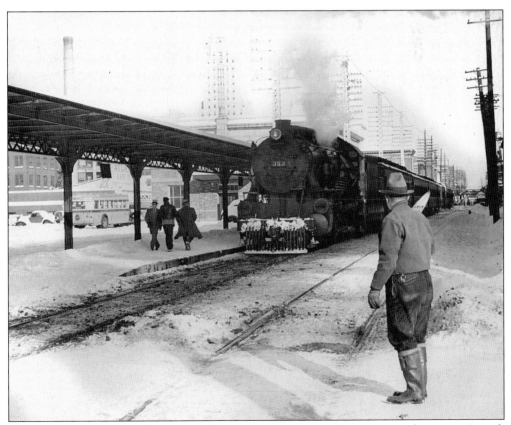

No. 353 at Franklin Street Station heads a "Santa Claus Special." Arriving under a vast 13-track train shed at Reading Terminal, shoppers go downstairs for a bite at Horn & Hardart Automat. Across Market Street are the holiday wonders of Woolworth's and John Wanamaker—a mighty Wurlitzer organ, a towering electric Christmas card that portrays the Nutcracker and Frosty the Snowman, a space-age monorail that circles a whole floor full of toys, and a big brass eagle on the main floor.

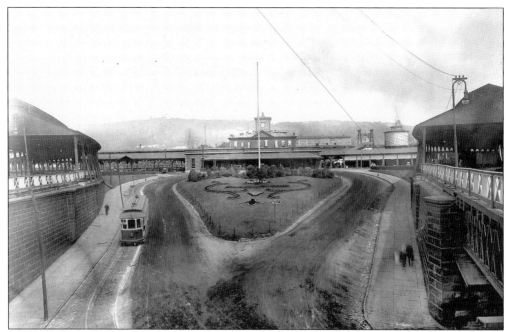

The Outer Station, built in 1874, was located in the middle of a wye formed by the diverging Lebanon Valley Branch and the Pottsville-Philadelphia main line. Once, 74 daily trains stopped here. What a grand sight this station was!

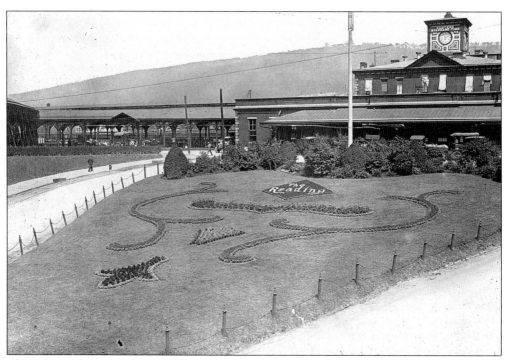

This is the Sixth Street lawn. Paul Huefner, company florist, and Robert Eiler, gardener, transplanted 14,000 flowers each June from a railroad hothouse at Wayne Junction, Philadelphia.

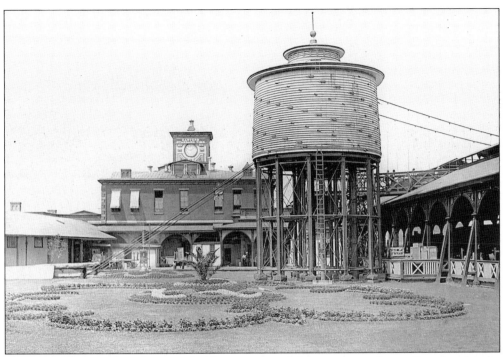

The south lawn displays their touch. That water tank has no spout. It supplies plugs by the platforms. Guy wires behind it support a tower of the Swinging Bridge, and the bridge spans the yard, extending to Eighth Street.

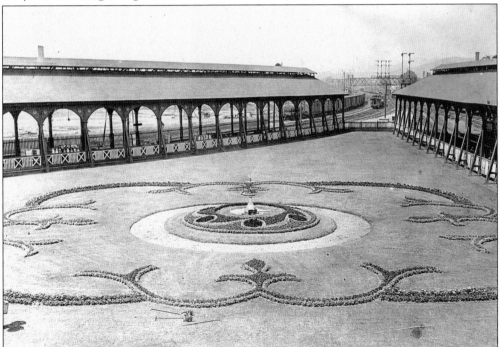

This is the north lawn. The Lebanon Valley Branch curves to meet the Pottsville-Philadelphia main line. Landscaping was different each year.

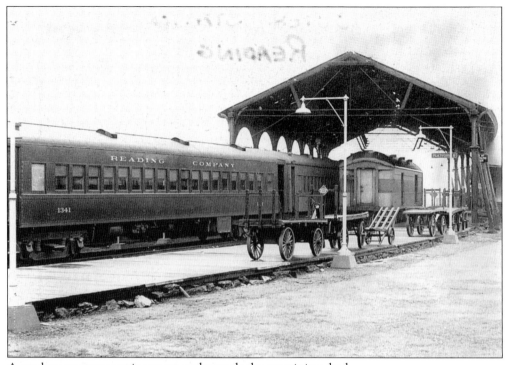

A modern passenger train pauses underneath the remaining shed.

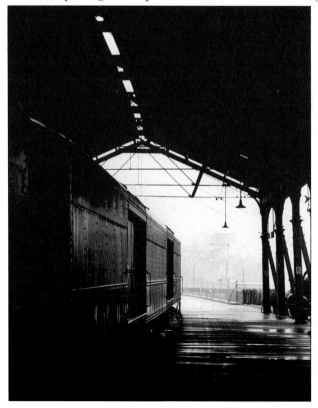

Baggage cars did a brisk business at the Outer Station. They hauled passengers' bags and trunks as well as freight items.

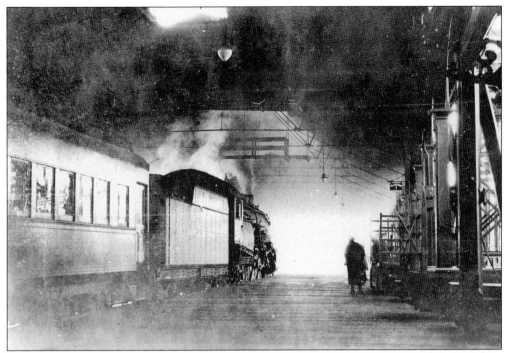

A lanky Reading 4-6-2 pauses at the Outer Station. Imagine the thumping of the air brake pumps, the hiss of steam from the cylinder cocks, the clank of the firebox door, and the acrid smell of coal smoke, all amplified under the shed.

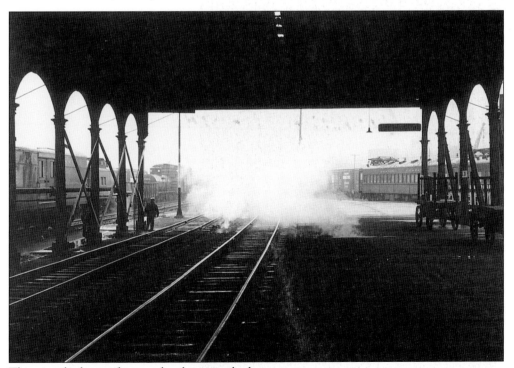

This view looks out from under the train shed.

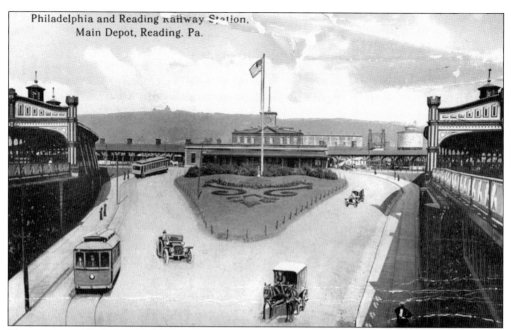

Transportation by horse, trolley, automobile, and train kept the Outer Station busy.

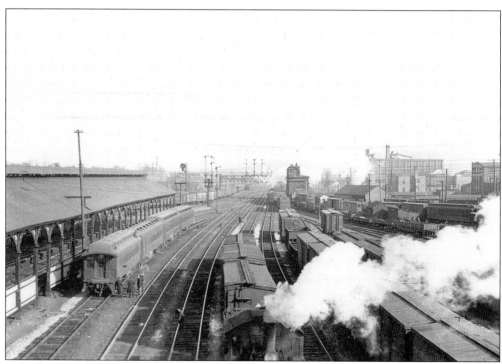

A shifter moves a cut of cars by the main line train shed. This view looks north from the Swinging Bridge, constructed by John A. Roebling Sons, who built the Brooklyn Bridge.

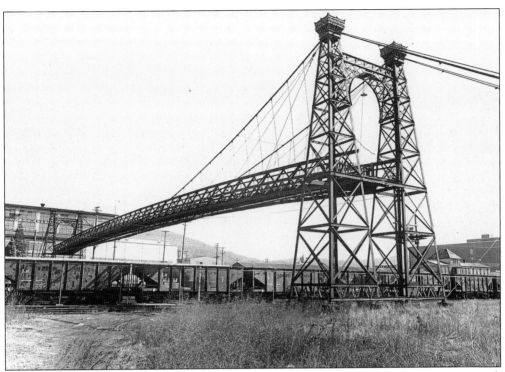

After the Outer Station was closed in 1969, steps to the Swinging Bridge were removed. This photograph was taken in 1973. Both towers and the deck stood until 1983, when they were dismantled.

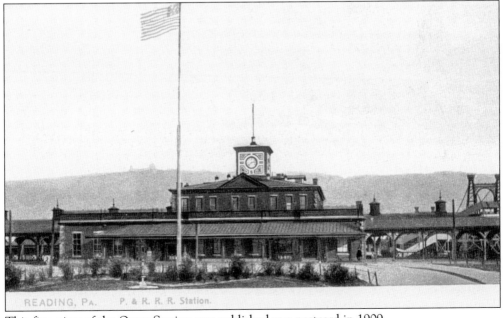

This fine view of the Outer Station was published as a postcard in 1909.

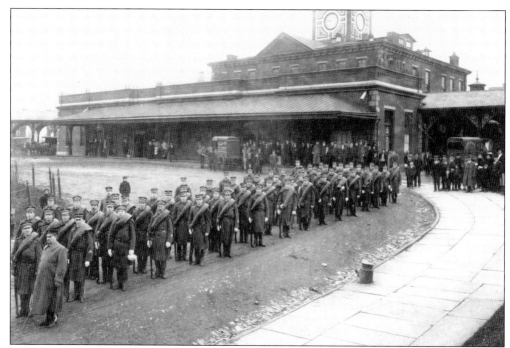

On March 2, 1909, the Pennsylvania National Guard, Company A, Reading, Captain Allen, commander, assembled at the Outer Station and boarded a train for the inauguration of Pres. William Howard Taft in Washington, D.C.

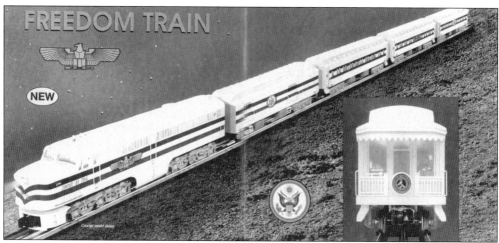

On November 18, 1947, the *Freedom Train* brought the Declaration of Independence, the Bill of Rights, and other historic documents to the Outer Station. More than 10,000 visitors came. The American Locomotive Company (Alco) and General Electric provided a PA-1. The Santa Fe, the Pennsylvania, and Pullman provided special cars. More than 20 Marines guarded these treasures. The train was sponsored by the American Heritage Foundation. Pictured is a Lionel model of the *Freedom Train*. (Courtesy Lionel.)

74

Five

RAMBLES

No. 2124 simmers in Reading, where it was built as the 25th of 30 T-1 4-8-4s in 1947. On May 2, 1959, No. 2124 and No. 2100 were displayed for visiting railfans. Once again, a steam-powered fan trip was suggested. On October 25, 1959, No. 2124 headed the first of 51 Iron Horse Rambles that would run through 1964. Today, No. 2124 stands by Steamtown's parking lot in Scranton, Pennsylvania.

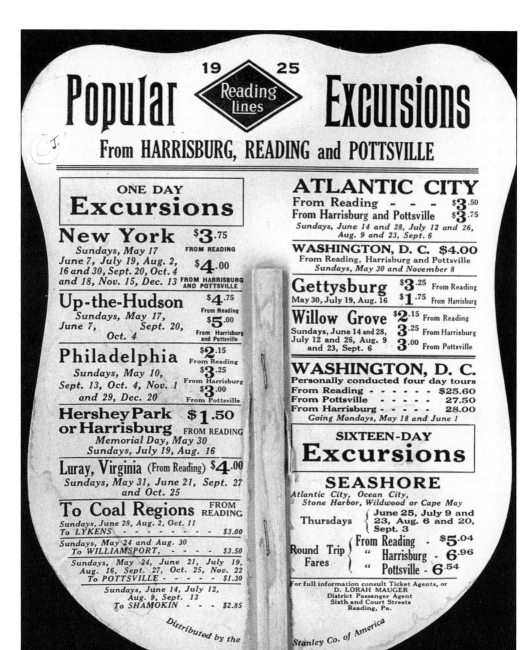

Popular Reading Lines Excursions — 1925

From HARRISBURG, READING and POTTSVILLE

ONE DAY Excursions

New York $3.75 FROM READING
Sundays, May 17
June 7, July 19, Aug. 2,
16 and 30, Sept. 20, Oct. 4
and 18, Nov. 15, Dec. 13 $4.00 FROM HARRISBURG AND POTTSVILLE

Up-the-Hudson $4.75 From Reading
Sundays, May 17,
June 7, Sept. 20,
Oct. 4 $5.00 From Harrisburg and Pottsville

Philadelphia $2.15 From Reading
Sundays, May 10, $3.25 From Harrisburg
Sept. 13, Oct. 4, Nov. 1 $3.00 From Pottsville
and 29, Dec. 20

Hershey Park or Harrisburg $1.50 FROM READING
Memorial Day, May 30
Sundays, July 19, Aug. 16

Luray, Virginia (From Reading) $4.00
Sundays, May 31, June 21, Sept. 27 and Oct. 25

To Coal Regions FROM READING
Sundays, June 28, Aug. 2, Oct. 11
To LYKENS - - - - - - $3.00
Sundays, May 24 and Aug. 30
To WILLIAMSPORT, - - - - $3.50
Sundays, May 24, June 21, July 19,
Aug. 16, Sept. 27, Oct. 25, Nov. 22
To POTTSVILLE - - - - $1.30
Sundays, June 14, July 12,
Aug. 9, Sept. 13
To SHAMOKIN - - - $2.85

Distributed by the

ATLANTIC CITY
From Reading - - - $3.50
From Harrisburg and Pottsville $3.75
Sundays, June 14 and 28, July 12 and 26,
Aug. 9 and 23, Sept. 6

WASHINGTON, D. C. $4.00
From Reading, Harrisburg and Pottsville
Sundays, May 30 and November 8

Gettysburg $3.25 From Reading
May 30, July 19, Aug. 16 $1.75 From Harrisburg

Willow Grove $2.15 From Reading
Sundays, June 14 and 28, $3.25 From Harrisburg
July 12 and 26, Aug. 9 $3.00 From Pottsville
and 23, Sept. 6

WASHINGTON, D. C.
Personally conducted four day tours
From Reading - - - - - $25.60
From Pottsville - - - - 27.50
From Harrisburg - - - - 28.00
Going Mondays, May 18 and June 1

SIXTEEN-DAY Excursions

SEASHORE
Atlantic City, Ocean City,
Stone Harbor, Wildwood or Cape May
Thursdays { June 25, July 9 and 23, Aug. 6 and 20, Sept. 3

Round Trip Fares { From Reading - $5.04
" Harrisburg - 6.96
" Pottsville - 6.54

For full information consult Ticket Agents, or
D. LORAH MAUGER
District Passenger Agent
Sixth and Court Streets
Reading, Pa.

Stanley Co. of America

This fan advertises popular excursions of 1925.

Depicted on this fan is the scenery on the way to New York City. Ferries connected Jersey City Terminal with Manhattan.

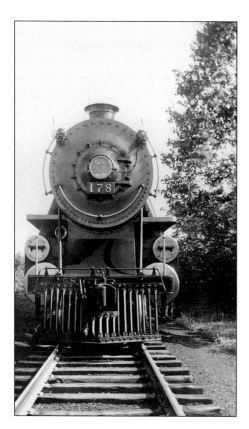

As the Great Depression eased its grip, the Reading offered a series of Rail Rambles. No. 178, newly streamlined in the Reading Shops, headed the first one on October 4, 1936. Its sleek lines and big boiler were well-suited to Rail Rambles, and it drew that duty until World War II, when unprecedented demands on all available equipment to move men and materiel brought Rambles to a halt.

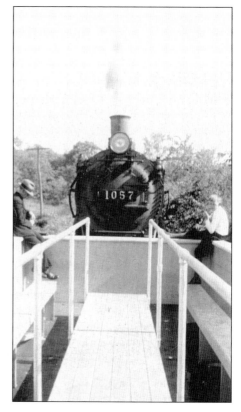

Rail Rambles traveled unusual routes ("rare mileage"), and this gondola equipped with benches was a great place to see scenery and listen to locomotives. This Ramble required Long John 2-8-0 No. 1057 for push-up duty on stiff grades. Imagine riding there, a few feet in front of a hard-working steam locomotive.

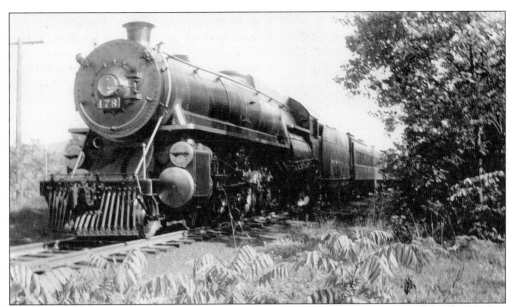

This is a three-quarter view of No. 178 heading a Rail Ramble. Note the air horn under the left running board, above the cylinder, also evident in the photograph to the left.

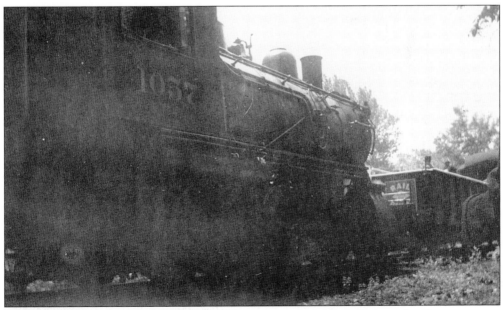

This view offers a glimpse of the Rail Rambles sign on the end of the gondola. On a passenger car, that sign would be a drumhead hung on the gate across the vestibule.

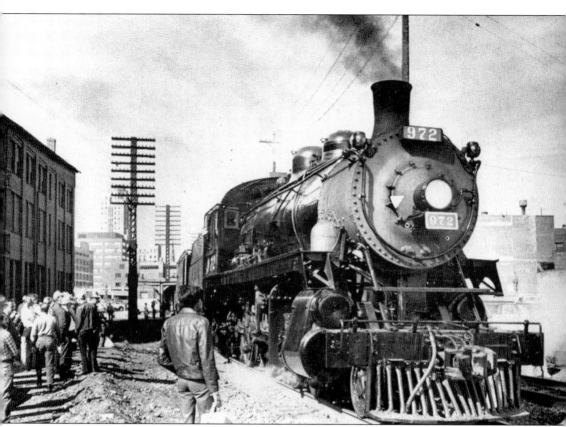

No. 972 is ready to depart Franklin Street Station on September 27, 1983.

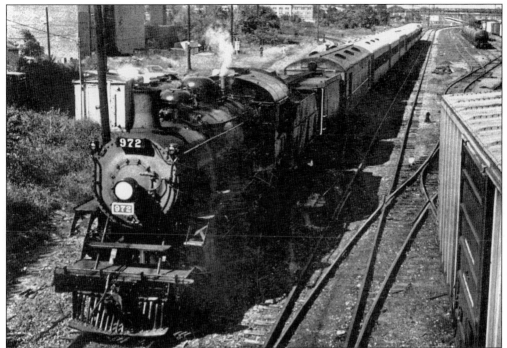

In 1983, the Historical Society of Berks County brought back the good old days by running George Hart's former Canadian Pacific 4-6-0 No. 972 and former Reading coaches from Jim Thorpe to Reading for Rail Rambles in celebration of the 150th anniversary of the P&R's April 4, 1833, charter. Here, the train leaves the Walnut Street yard, heading toward the Seventh Street cut. On the left, the train waits to depart Franklin Street Station. Below, the train crosses Peacock's Lock Bridge on its way to Pottsville on October 1.

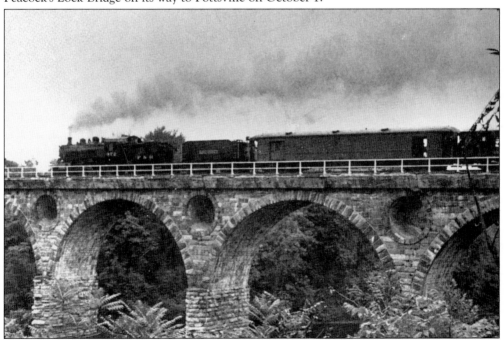

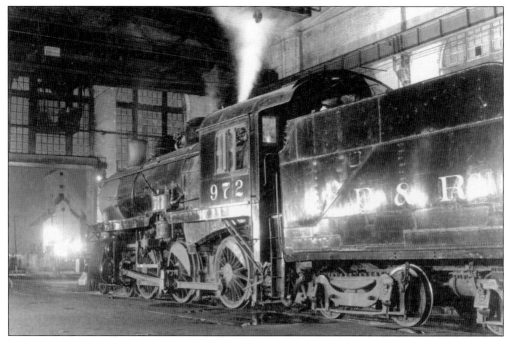

Between excursions, No. 972 and the entire train backed into the locomotive shop with room to spare. That presented an opportunity for shop tours. Amid crowds, one man told us, "Bless the people who did this. I'm a hero in my grandchildren's eyes again."

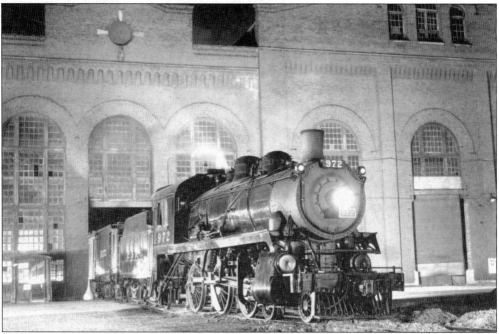

No. 972 poses outside the locomotive shop. This scene took place many times as a newly shopped locomotive was fired up and stretched its legs for the first time. Hundreds of iron horses were built and repaired here. A huge concrete coaling station, water plugs, and a sand house fed these steeds between runs in a complex called "the farm," north of the shops by the roundhouse.

Six

HORSECARS AND TROLLEYS

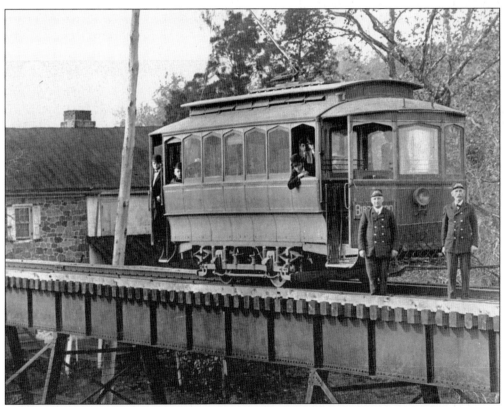

A Brill poses on a bridge in Birdsboro. This was an economical car. It was operated by one man, who served as motorman and conductor. It also required less power because it was smaller and lighter than a two-truck (or eight-wheel) car.

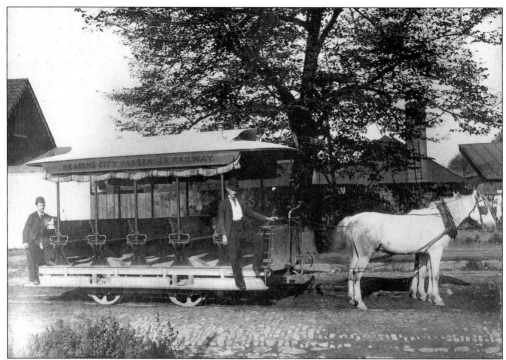

Before trolleys, passengers rode horsecars on city streets. This is a prime example from the Reading City Passenger Railway. Rails reduced friction, and horsecars were easier to pull than wagons or omnibuses.

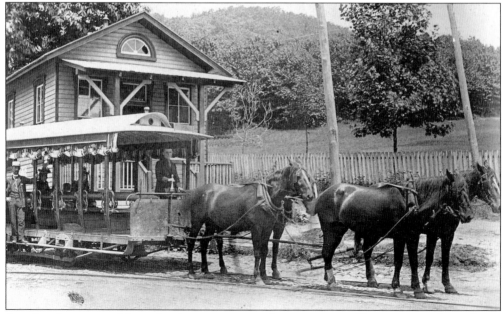

Another horsecar with a four-horse team awaits passengers. Companies took pride in their horses.

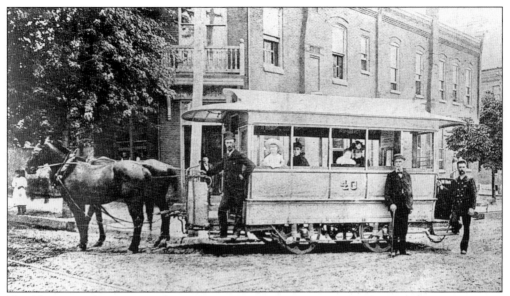

No. 40 poses with its crew and passengers.

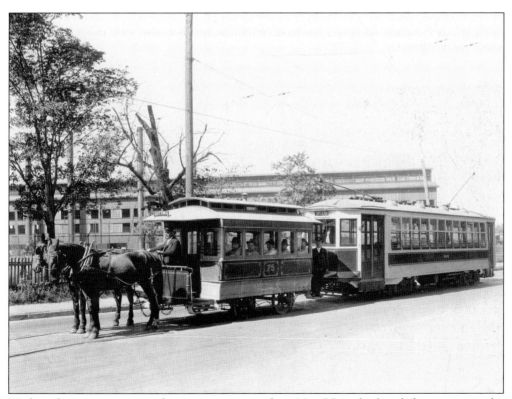

Modes of transport past and present pose together. No. 75 is displayed downstairs in the Historical Society of Berks County in Reading. Sadly, that splendid trolley is long gone.

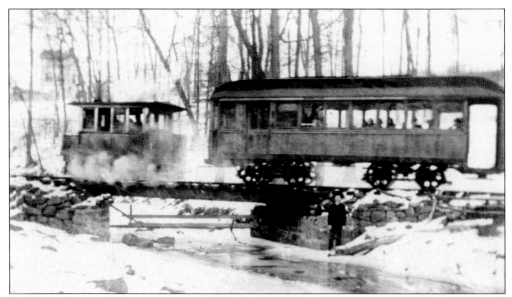

In this c. 1904 photograph, a steam dummy pulls a trolley-like coach west of Mohnton (Mohnsville), approximately a half-mile southeast of the Shillington water-treatment plant. The house in the left center adjoins Madison Avenue two blocks from the plant. The house and property were owned by Adam and Louise Hoyer. Adam stands below the coach.

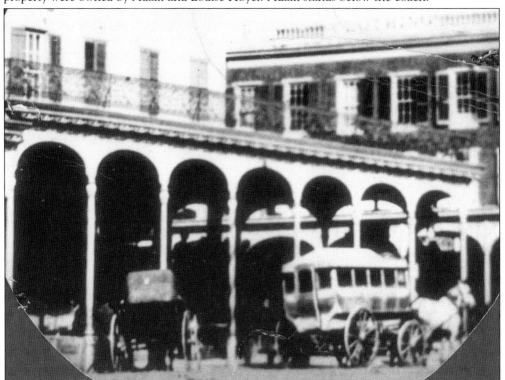

This blurry view preserves a horse-drawn omnibus designed to ferry passengers and their baggage to hotels and resorts. It is high and narrow to facilitate turning and maneuvering through city traffic.

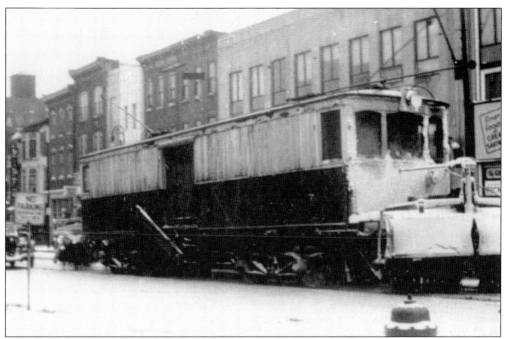

Trolley companies kept city streets clear of snow. The Reading Street Railway two-truck (eight-wheel) snow sweeper No. 676 or 678 is on the job at 10th and Penn Streets. A motor inside each end turns each sweep, or rotary, broom. This big unit looks as though it could handle a blizzard.

This is a single-truck (four-wheel) sand car. Loaded into bins on a trolley, sand is released through small pipes to increase traction on wet rails. Locomotives and school buses do the same thing.

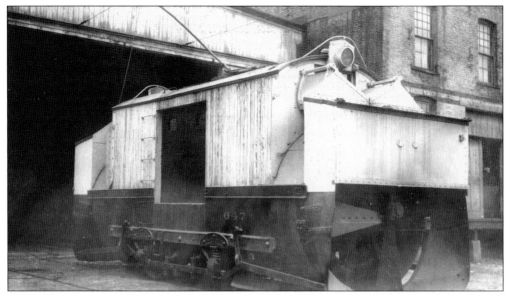

Few trolley companies had rotary snowplows because flying snow could harm pedestrians and damage nearby buildings, windows, and cars. The Reading Traction Company had two—this big plow and a smaller one on the next page.

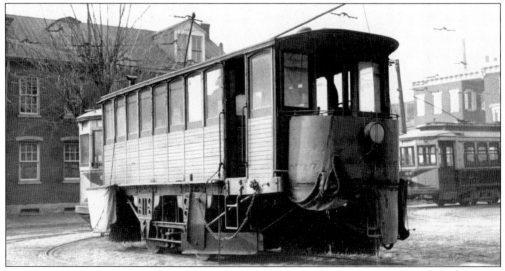

Single- and double-truck snow sweepers were much more common. Some companies built their own.

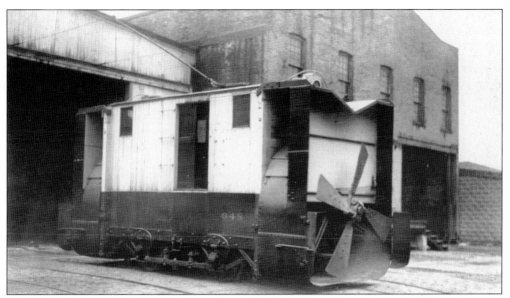

This small rotary snowplow was a most unusual car. Few traction companies had them because of the risk of injuries and damage from flying snow on crowded city streets.

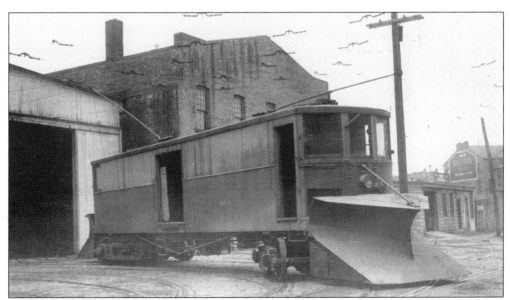

Another common snow mover was a plow, usually a self-propelled version of a railroad Russel, or bucker, plow pushed by locomotives.

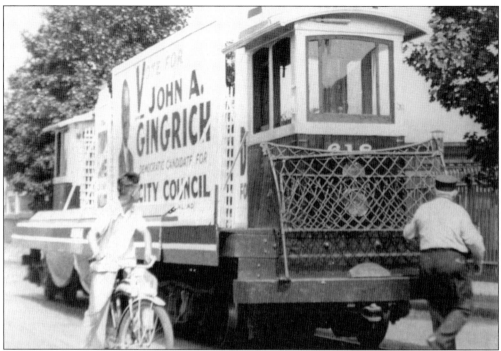

Under that campaign sign is No. 618 at Sixth and Amity, a flat motor work car used to haul rails and poles for the overhead wire. A cab at each end provided good visibility. Only Daniel Angstadt was authorized to run this car because it handled differently than regular trolleys.

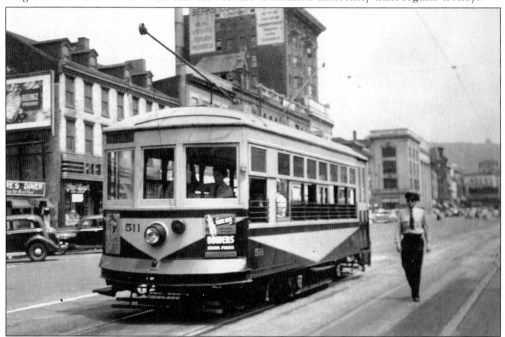

Built by Osgood-Bradley in 1920, Reading Street Railway Company No. 511 pauses at Fourth and Penn later that year, running between Reading and Norristown. A Birney safety car carries up to 30 passengers.

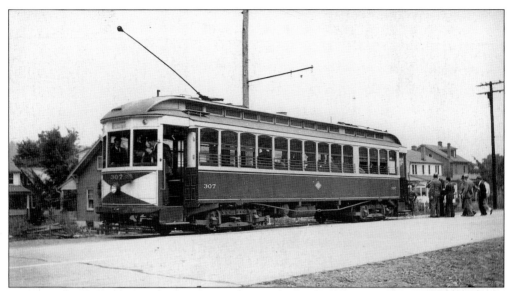

Reading Street Railway Company No. 307 stops at the Stony Creek terminus in 1939. This car was built by Brill in 1901 as Oley Valley Combine No. 7, carrying a combination of passengers, baggage, and freight. It has been rebuilt as a 56-passsenger coach. Shortly after this photograph was taken, trolley service between Pennside and Stony Creek ended.

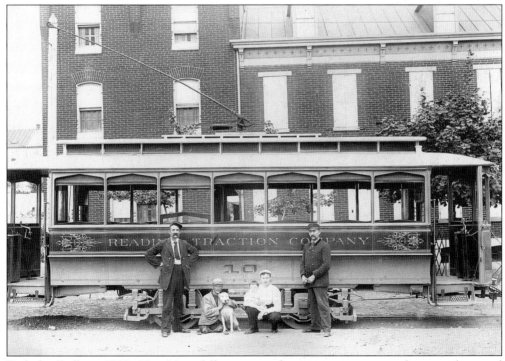

Built by Brill in 1893, No. 10 artfully poses with a motorman, a conductor, a boy, and a dog.

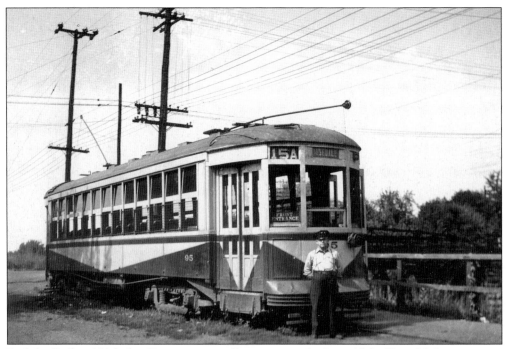

Built by Brill in 1916, this 52-passenger trolley pauses at the Laureldale (Rosedale) terminus at Elizabeth Avenue.

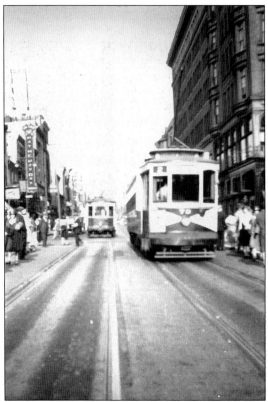

In this view, looking east at Sixth and Penn Streets, two trolleys pass Pomeroy's (right).

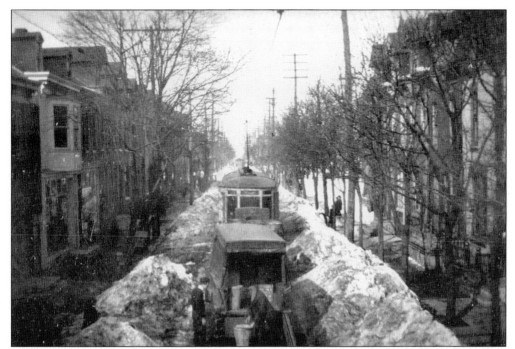

Five cars are caught in this tie-up on Schuylkill Avenue, looking from Green Street to Oley, in February 1925.

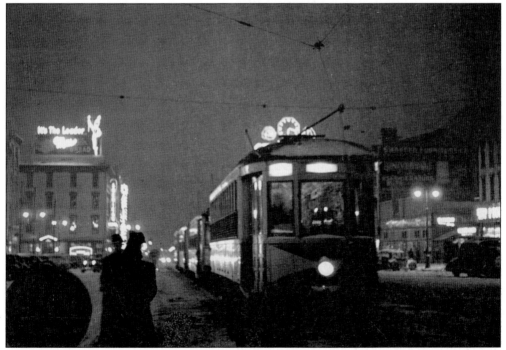

This is the evening rush hour at Fourth and Penn c. 1938.

Built in 1901, a 300-series Oley Valley trolley rolls along the Boyertown line near Carsonia Park. This line was abandoned in 1932. A little locomotive from Carsonia Park found its way to the Reading Society of Model Engineers, and they keep it running.

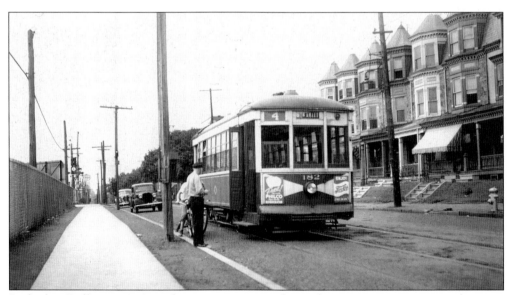

Built by Brill in 1916 with two motors and 80 horsepower, maroon and cream No. 182 opens its doors on North Sixth Street, near the Reading Shops, on the Sixth and Amity line.

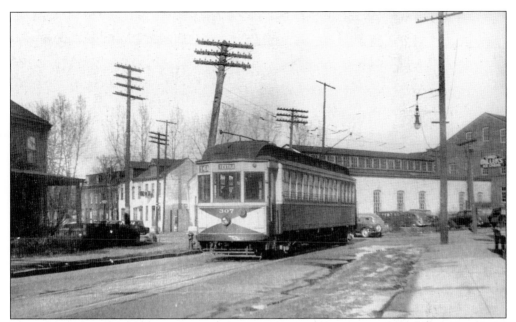

Another Oley Valley car, No. 307, runs past an old paint shop at Ninth and Moss Streets on a textile trip on February 26, 1941. Built in 1901, this maroon and cream 56-passenger car ran until 1947.

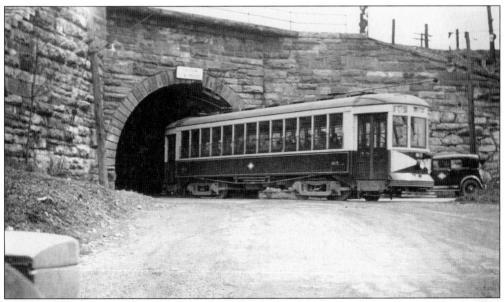

At George Field, Reading Street Railway Company No. 95 emerges at Sixth and Richmond Streets (Hiester's Lane) on its route from Temple to Penn Square at Fifth and Penn Streets. No. 95 is maroon and cream. The northern approach to the Reading yard is atop the bridge. A company car with a Reading Transit Company diamond herald is heading north.

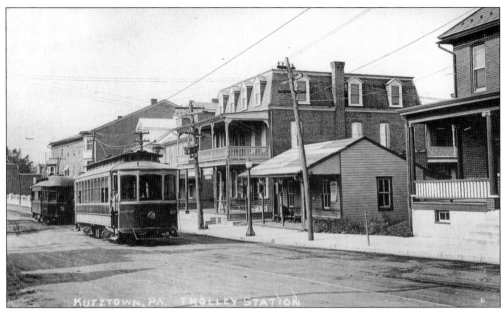

Kutztown once had a trolley station where cars from Reading met cars from Allentown.

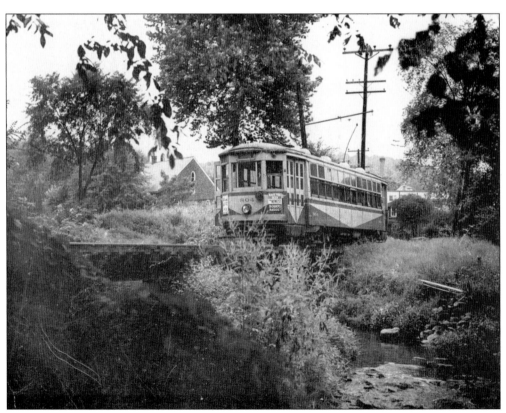

No. 804 in a bow tie paint scheme stops at Mohnton.

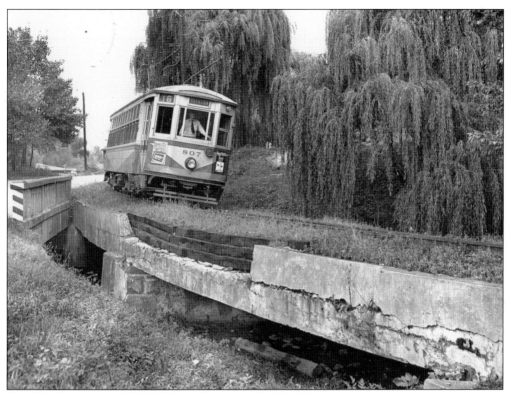

No. 807 is running on the Mohnton line, near Pennwyn.

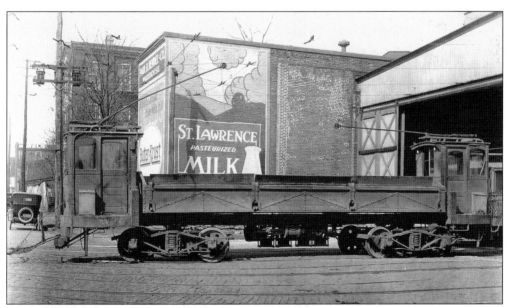

Big archbar trucks identify Differential Dump Car Company, the same car being loaded with snow on page 16. The photograph clearly shows details, plus advertisements painted on the building and a car parked on the street.

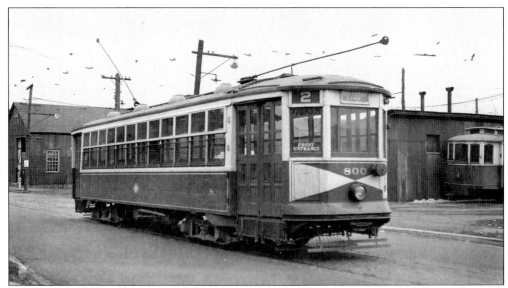

This elegant maroon and cream 45-passenger beauty was built in the Reading Transit Company shops on Exeter Street, where we see it now. No. 800 was the first 800-series car to be scrapped, early in 1947.

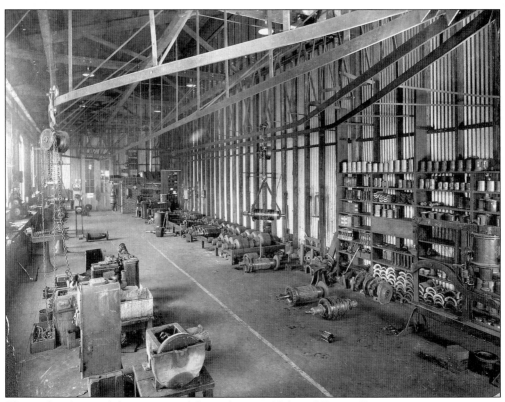

This is the electrical department of the carbarn at 10th and Exeter Streets.

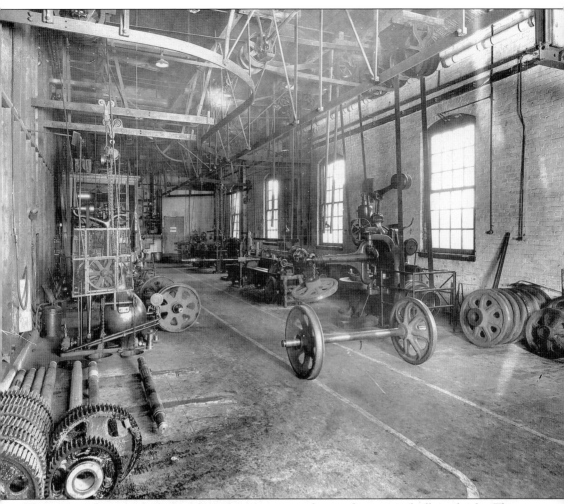

This repair shop view shows transmission gears, axles, and a pair of idler wheels. They are seldom seen because they are mounted inside trucks, out of sight, next to barrel-size electric motors.

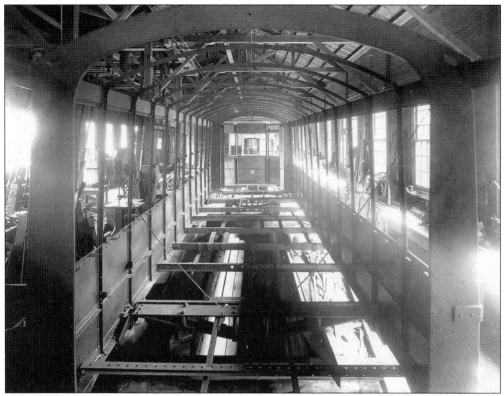

This is the framework of a trolley under construction in the carbarn at 10th and Exeter.

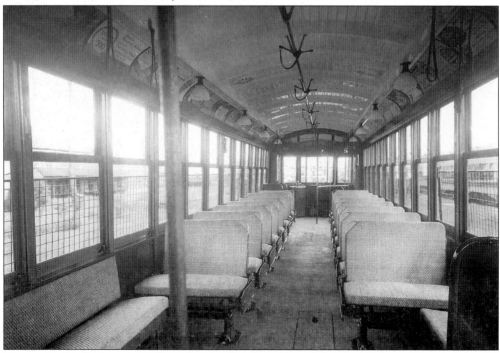

This is the finished product. Note the car cards.

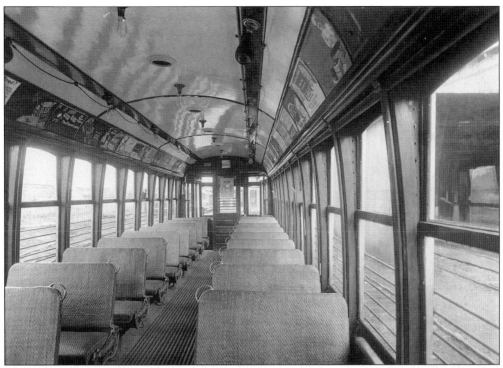

The roof is so new it shines.

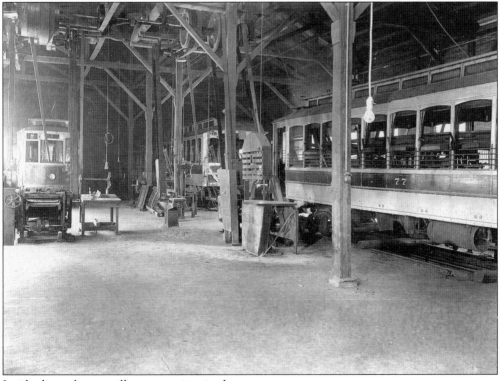

Inside the carbarn, trolleys are maintained.

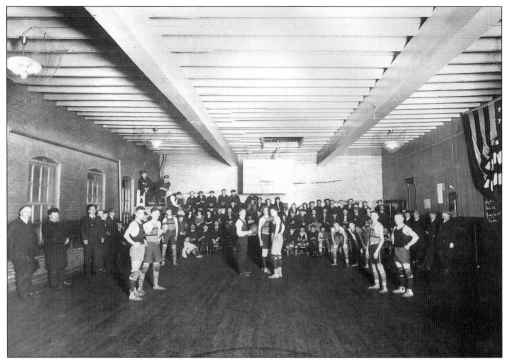

These basketball teams played on the second floor of a carbarn probably at 10th and Exeter Streets.

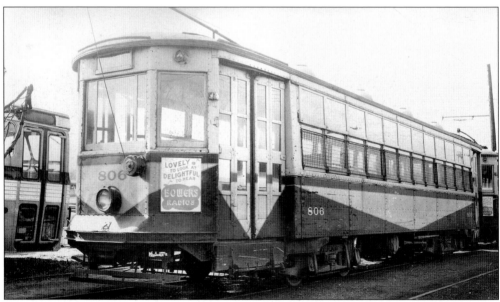

No. 806 was built in the Reading Transit Company shop at 10th and Exeter in 1923, using parts purchased from Brill. This 45-passenger car was among the last constructed for the RTC. In 1952, the Mohnton line was abandoned, No. 806 was scrapped, and the bus on the left took over.

Seven

GENERAL SCENES

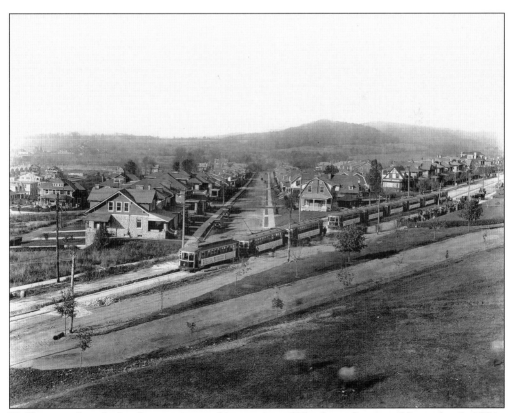

Trolleys stand ready for the opening and inspection of Northeast Loop on November 1, 1924.

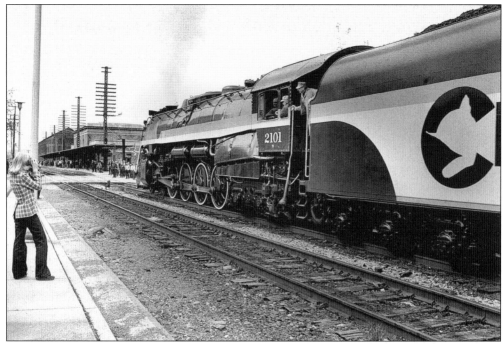

No. 2101 chuffs down Seventh Street toward Franklin Street Station in April 1978. It received major running gear and boiler repairs for the *Chessie Steam Special* by a crew of volunteers and eight full-time men, aided by Frank Katrinak (the locomotive shop night foreman in 1945) and Joe Karal (a Nickel Plate boilermaker) in the Reading Shops. That female photographer honors the memory of editor Freeman Hubbard, who published pictures of comely railfans in *Railroad* magazine.

According to the words of a veteran engineer, "3 mph is a coupling. 4 mph is a collision." This gondola was hit harder than that. A locomotive or a car was moving way too fast.

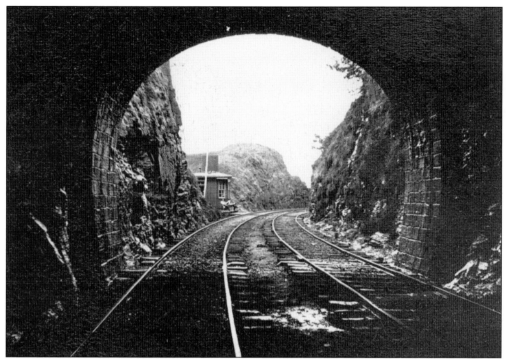

This is the view from Black Rock Tunnel along the P&R main line, north of Phoenixville.

This is the portal of Black Rock Tunnel. Still busy, this tunnel has been enlarged, and two tracks have been changed to one center track for high-clearance cars.

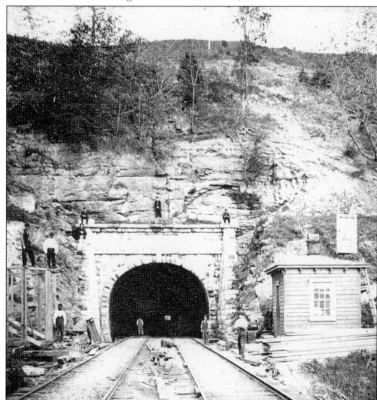

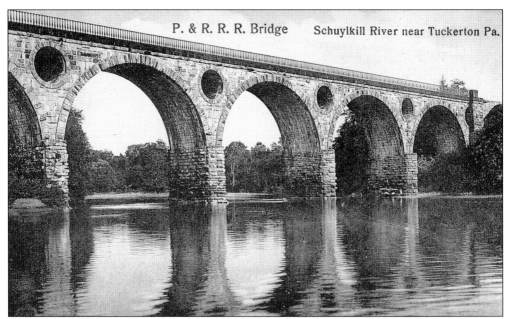

P. & R. R. R. Bridge Schuylkill River near Tuckerton Pa.

Mailed in April 1915, this postcard presents a superb view of Peacock's Lock Bridge on the main line above Tuckerton. It replaced a wooden truss bridge built in 1839. Philadelphia & Reading general superintendent Gustavus A. Nicolls designed this bridge and completed it in 1855–1856, when the contractor failed to do the job. This is believed to be the only pierced spandrel bridge in America.

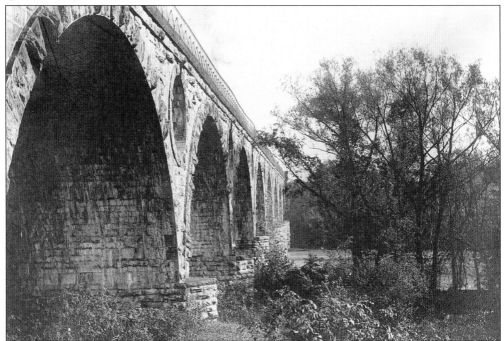

This closeup conveys the grace and beauty of Peacock's Lock Bridge. On a sunny morning, passengers could look down upon the Schuylkill River, 64 feet below, and see a shadow of their train crossing these majestic arches.

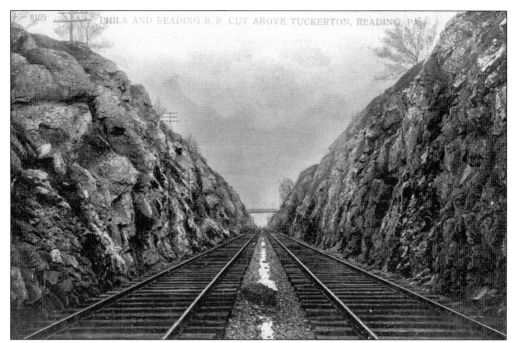

Just as heavy rock work was necessary at Klapperthal, a lengthy cut was required to keep the track level above Peacock's Lock Bridge.

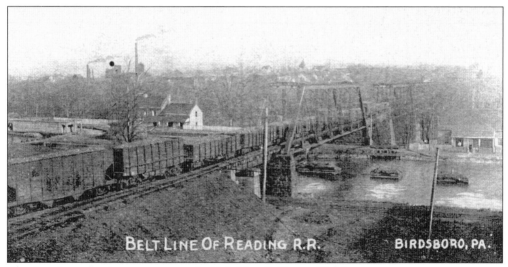

BELT LINE OF READING R.R. BIRDSBORO, PA.

A train of wooden hoppers crosses the Belt Line Bridge at Birdsboro.

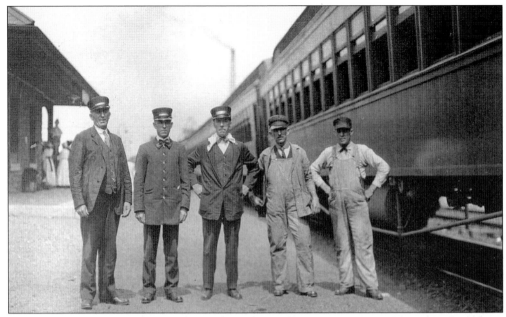

A passenger train crew poses with wooden cars. Perhaps one is No. 90849, now the *Cherry Hill* (No. 58), running on the Strasburg Rail Road, where Reading business car No. 10 is open for tours.

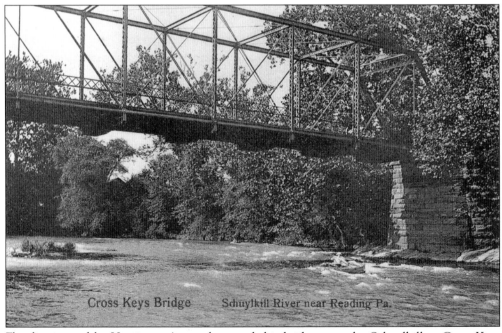

Cross Keys Bridge Schuylkill River near Reading Pa.

Flooding caused by Hurricane Agnes destroyed this bridge over the Schuylkill at Cross Keys in June 1972, but spared a similar bridge built of Carnegie steel 10 miles upriver—Bern Station Bridge.

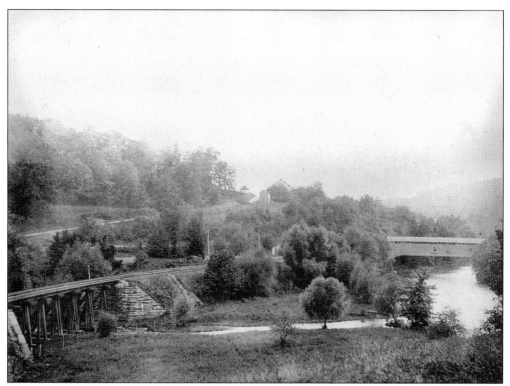

This is a pretty scene along the Schuylkill & Lehigh. The covered bridge spans Sacony Creek.

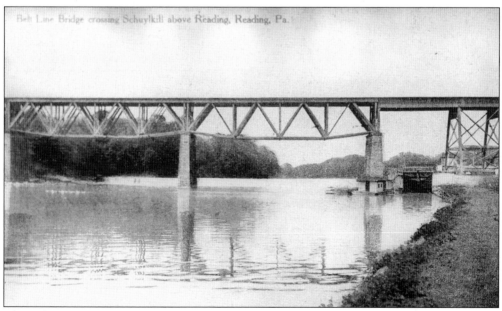

The Belt Line Bridge crosses Shepp's Dam, built in 1833 and removed in 1950.

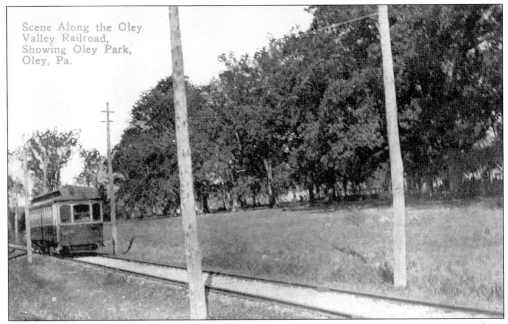

A two-truck (eight-wheel) trolley is running on the Oley Valley Railroad at Oley Park in eastern Berks County.

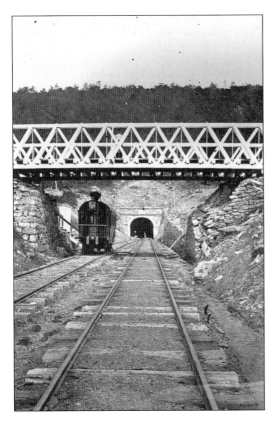

This interesting scene includes a bridge, an inspection engine, and a tunnel.

The Pennsylvania Railroad hauled everything. This is a snow train headed by a Class D 4-4-0, one of 429 built by the Standard Railroad of the World. This train is not plowing snow but hauling it away from Reading. A lot of shoveling was necessary to load those cars. (For a closeup of a freight motor pressed into this service, see page 16.)

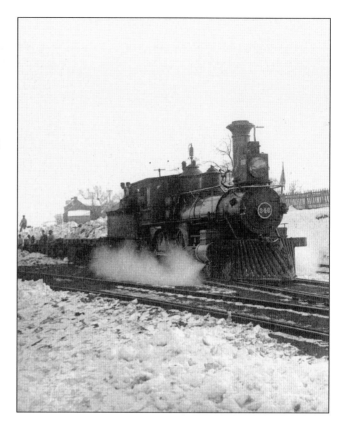

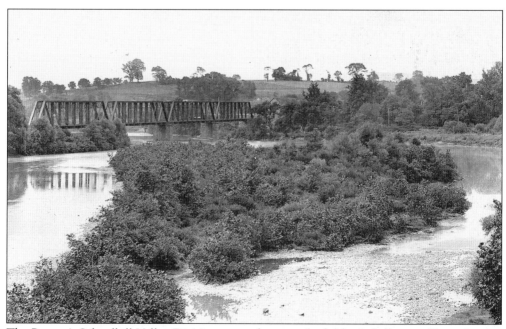

The Pennsy's Schuylkill Valley Division was a showcase for bridges of all types. Here, three in a row provide access to Reading.

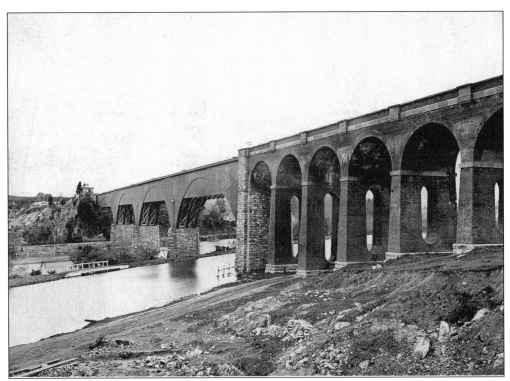

This Lebanon Valley Railroad bridge was burned during the Great Railroad Strike of 1877.

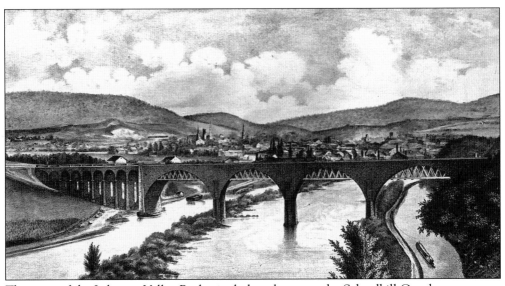

This view of the Lebanon Valley Bridge includes a barge on the Schuylkill Canal.

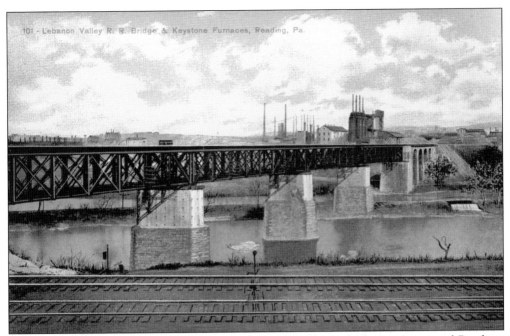

This is the replacement for the bridge burned in 1877. We are looking east, toward Reading. Keystone Furnaces are visible beyond the bridge.

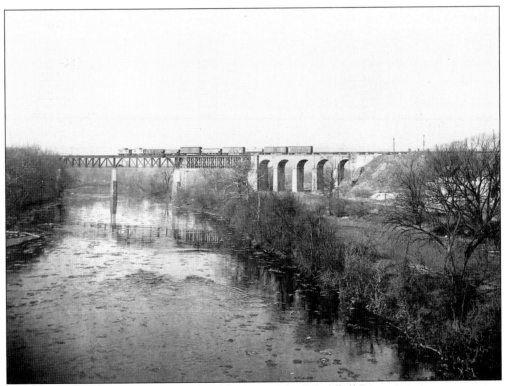

This view includes two cabooses and a reflection in the Schuylkill River.

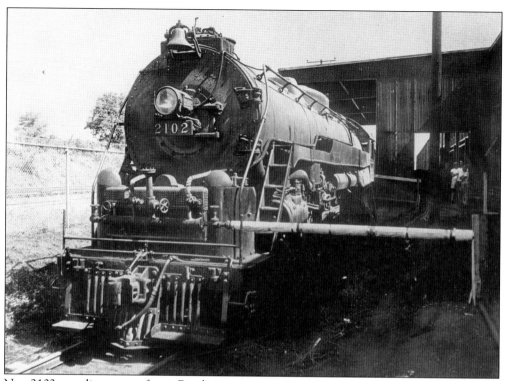

No. 2102 supplies steam for a Reading customer. Stored at Port Clinton while awaiting restoration, No. 2102 last ran in 1991 for owner Reading & Northern.

Built at the Reading Shops in 1948, G-3 Pacific No. 215 rounds Klapperthal Curve with a passenger train.

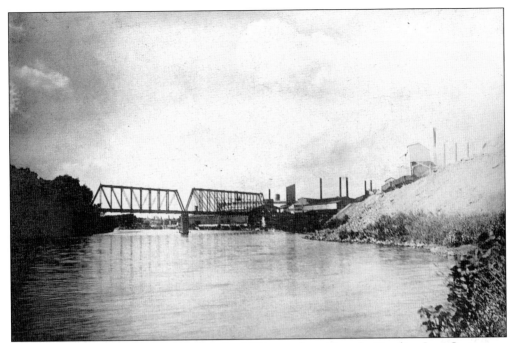

The Spruce Street Bridge, destroyed in the 1970s, was located at the Reading Iron Company, along the Schuylkill River. Neversink Mountain is on the right.

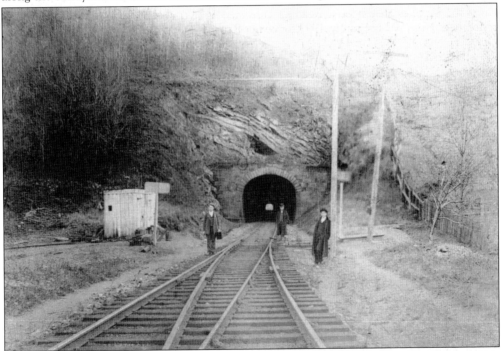

Port Clinton, 20 miles north of Reading, demanded two engineering feats. The first was this tunnel, constructed in 1840 at great expense. When locomotives and cars outgrew it, the Reading bypassed it by moving 330,000 cubic yards of earth and rock in two years (from 1924 to 1926), forming a fill that eliminated an inconvenient bow in the Schuylkill River.

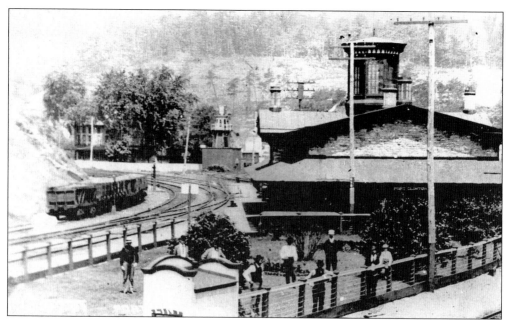

By 1899, Port Clinton had a frame 20- by 44-foot passenger station and plenty of traffic. Take in all the details, including a windmill tower that displayed signals for train movements.

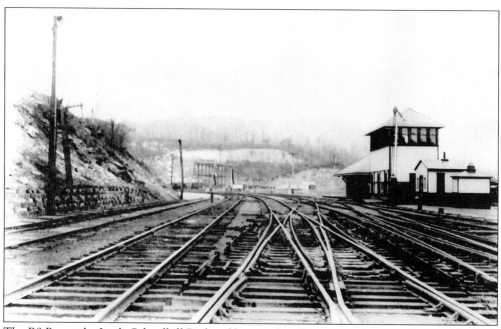

The P&R met the Little Schuylkill Railroad here and used its engine house and turntable. Both have been rebuilt by the Reading, Blue Mountain & Northern. Stone-walled inspection pits that were built in the 1830s between rails in the engine house are visible. They were in use when the P&R was under construction.

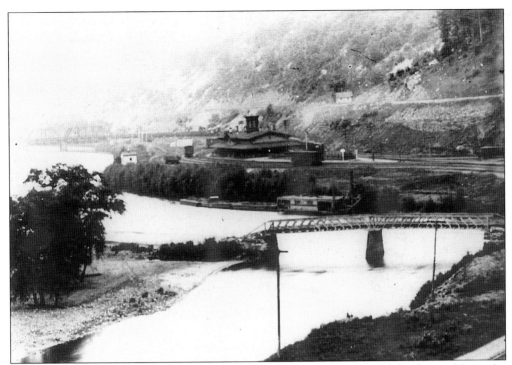

The Schuylkill Canal was still in operation, and here we see the towpath bridge used by mules and horses to go from one side of the canal to the other. The Pennsylvania Railroad on the hillside cut is now part of the Appalachian Trail.

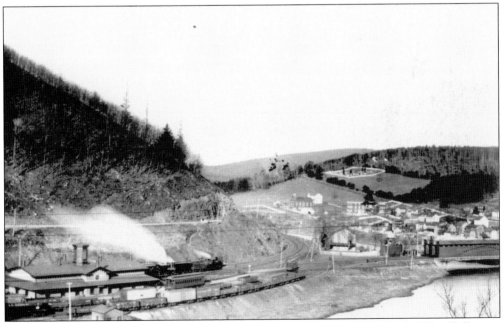

North of the station, the P&R main line to Pottsville turns left, and the Little Schuylkill turns right, following its namesake river on its way to Tamaqua. A railroad was built because the terrain to Tamaqua was too hilly for a canal, and there was insufficient water.

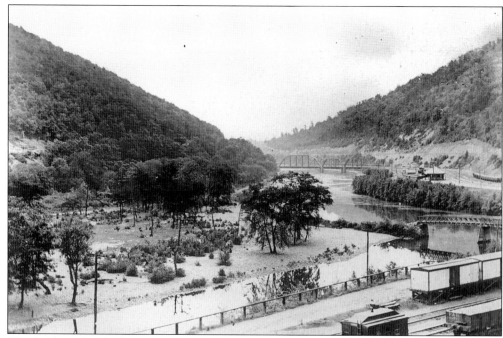

The Little Schuylkill covered bridge was washed down to the Blue Mountain Dam near Hamburg in the devastating floods of 1850 and then hauled back to its original location and used for another 40 years.

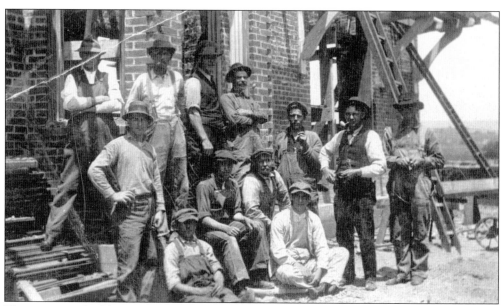

These men are building Berne Station in 1914.

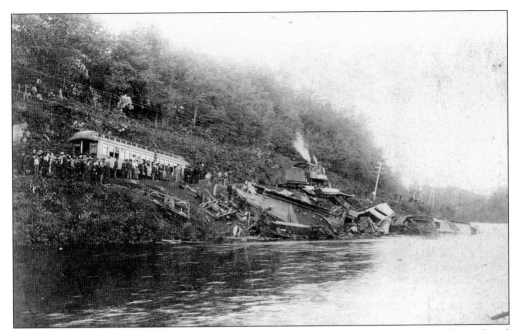

Around dusk, north of Shoemakersville, on September 19, 1890, the engine of a southbound coal train bumped the rear of another coal train, derailing a car and spilling coal on an adjacent track. Less than two minutes later, the northbound *Pottsville Express* hit the wreckage and plunged into the Schuylkill River, killing 22 people, including George Kaecher, the P&R's general counsel, who had been the official prosecutor in the Molly Maguire trials 14 years earlier.

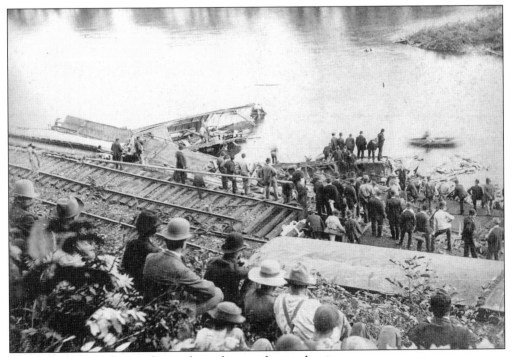

This hillside view shows splintered wooden coaches in the river.

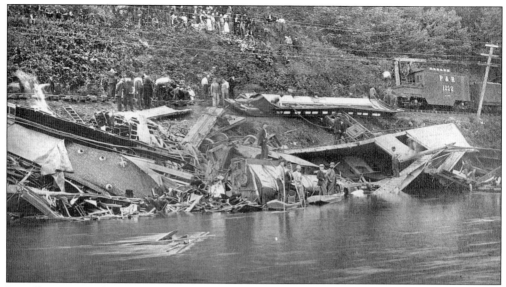

In collisions, wooden cars broke like kindling, dooming passengers. Rescue efforts continued through the night. Engineer John White's body was found underneath the firebox. Others were trapped beneath the cars on the muddy, grassy bottom of the river. This was one of the Reading's worst wrecks.

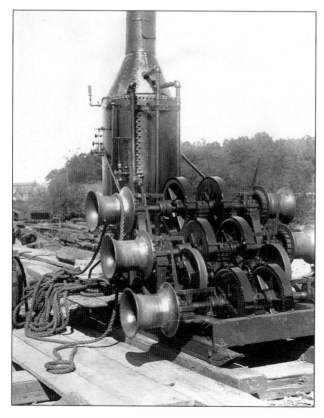

This picture of a steam donkey was filed with the wreck photographs seen on these pages, but an inscription says, "Exeter." Each spool acts as a winch, and heavy ropes are handy.

Eight

READING RAILROADS TODAY

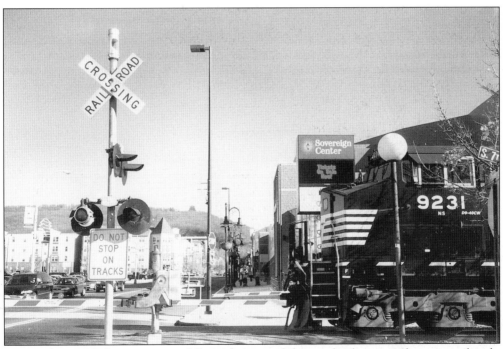

On April 1, 1976, Congress created Conrail to consolidate six bankrupt northeastern railroads, including the Reading. The Staggers Act of 1980 ended stifling regulations. By 1981, Conrail earned a profit. By 1996, Norfolk Southern and Chessie System each bid over $1 billion to acquire Conrail. Norfolk Southern got the Pennsylvania and the Reading. Chessie System got the New York Central. In this view, a Norfolk Southern train passes the Sovereign Center at Seventh and Penn. The Pagoda stands on Mount Penn.

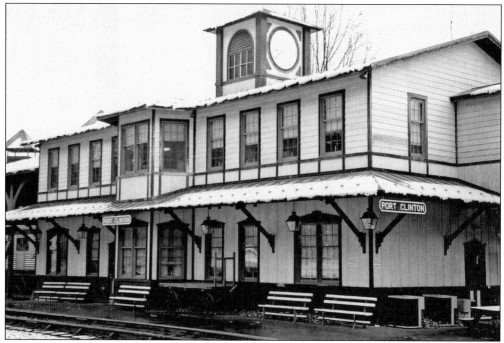

Modeled after the Outer Station, the Reading & Northern offices at Port Clinton operate some 300 miles of track from Reading to the coal regions, the Lehigh line from Lehighton to Scranton and Mehoopany, and even the Pennsylvania from South Hamburg to Temple. (Courtesy the Reading and Northern Archive.)

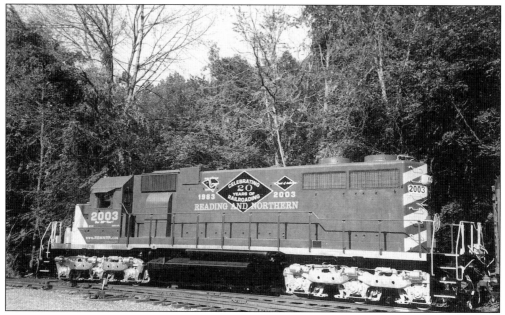

This is the Reading & Northern 20th-anniversary diesel. The R&N hosted more than 4,500 visitors during a 20th-anniversary open house at Port Clinton. An SD-38 was completely overhauled, painted, and lettered for the occasion, and it was christened *2003*. (Courtesy the Reading and Northern Archive.)

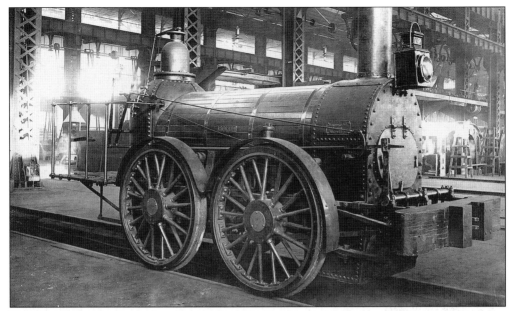

The *Rocket* is one of eight locomotives built by Braithwaite, Milner and Company of London in 1838. Seen here inside the locomotive shop, it may be on its way to the Franklin Institute in Philadelphia, where it rests today on a section of track from the first years of the P&R in the Train Factory, an interactive railroad room that features cab rides on 350-ton Baldwin 4-10-2 No. 60,000.

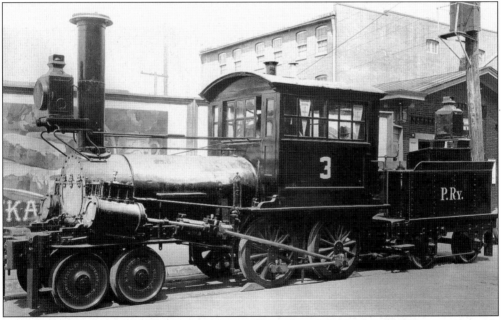

Near the *Rocket* in the Franklin Institute is People's Railway No. 3, an ancient locomotive with a mysterious past. No. 3 ran between Pottsville and Minersville. After serving as a shifter in Reading in the late 1800s, it was sent to a scrap line, where its age was discovered. About 160 years old, this 4-4-0 resembles the *Gowen & Marx*. Although that world-famous locomotive was scrapped, No. 3 (a comparative nobody) has been preserved.

This book was inspired by *Baseball in Reading,* by Charles J. Adams III, so we are glad to include a photograph of a Reading Phillies train-oriented logo. One of the best stadiums in baseball stands by a siding to Parish Frames and west of the P&R main line. From time to time, a recording of a melodious Reading G-1sa passenger whistle joins the crowd in cheers. (Courtesy the Reading Phillies.)

Lionel's O Gauge T-1 (No. 2100) stands amid Iron Horse Rambles memorabilia. The engineer's cap (with extra patches) and the record were given to Rambles passengers as souvenirs. In back are a large RALBAR album (right) and two rare albums by North Jersey Recordings. (Courtesy Dennis A. Livesey.)

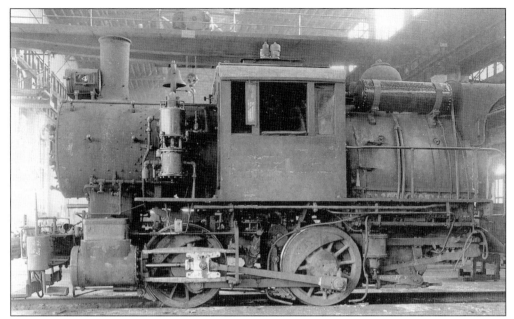

Only the Reading had 0-4-0 camelback shifters, and this is the last one, in the Reading Shops for repairs in 1953. Built by Baldwin in 1902 as No. 1187, it was owned by E. G. Brooke Plant of Colorado Fuel & Iron at Birdsboro and was renumbered as No. 4. Nine years later, it was sold to the Strasburg Rail Road. It now stands in the yard of the Railroad Museum of Pennsylvania at Strasburg as the last Reading camelback in existence.

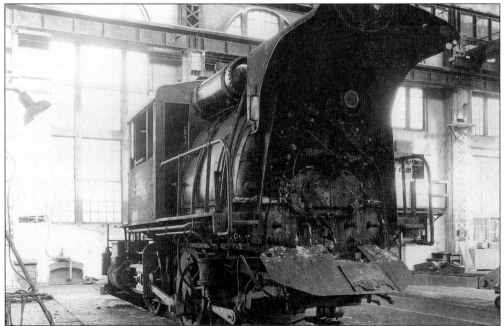

The photographer wisely snapped the rear of No. 4, a sight seldom seen. Two firebox doors were necessary for a fireman to shovel coal evenly throughout that wide Wootten firebox. Birdsboro stablemate 0-4-0T No. 2 (a 1920 Porter) was sold to the Wanamaker, Kempton & Southern, where it locks couplers with Combine No. 408, the first car on many an Iron Horse Ramble.

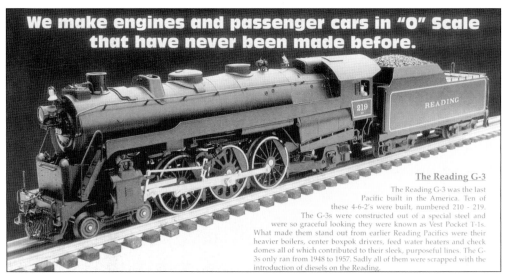

The Reading G-3

The Reading G-3 was the last Pacific built in the America. Ten of these 4-6-2's were built, numbered 210 - 219. The G-3s were constructed out of a special steel and were so graceful looking they were known as Vest Pocket T-1s. What made them stand out from earlier Reading Pacifics were their heavier boilers, center boxpok drivers, feed water heaters and check domes all of which contributed to their sleek, purposeful lines. The G-3s only ran from 1948 to 1957. Sadly all of them were scrapped with the introduction of diesels on the Reading.

In 1948, the Reading Shops completed their final new steam locomotives, 10 G-3 Pacifics, the last built in America. All were gone in 1957, but Glenn Buckner (of SGL Lines) offered the first three-rail O Gauge models of No. 210 and No. 219 as well as matching 2000-series turtleback, or blimp, cars. They run as smoothly as Hamilton watches. (Courtesy SGL Lines Electric Trains.)

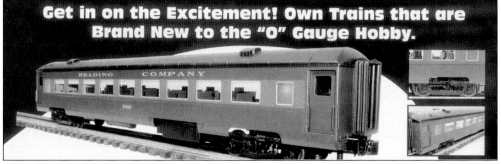

SGL Lines 2000-series turtleback passenger cars feature a black-and-white checkerboard pattern in the aisles. Seat colors vary: red for the *Schuylkill* (Pottsville to Philadelphia) and blue for the *King Coal* (Shamokin to Philadelphia). (Courtesy SGL Lines Electric Trains.)

Lionel's superb, smooth-running O Gauge T-1 (No. 2100) leads a passenger train across Starrucca Viaduct on Phil Klopp's layout. The real No. 2100 is for sale in Canada. No. 2101 is displayed in the B&O Railroad Museum, Baltimore, and No. 2124 is at Steamtown, Scranton. No. 2102 awaits restoration at Port Clinton. (Courtesy Dennis A. Livesey.)

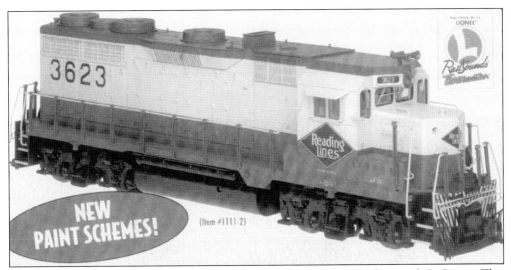

Atlas O has been bringing terrific cars, locomotives, and track to three-rail O Gauge. This three-quarter view from the company's catalog introduces new paint schemes in the GP-35 series. Note the fine details, including an Electro-Motive Division (EMD) builder's plate below the Reading Lines herald. (Courtesy Atlas O.)

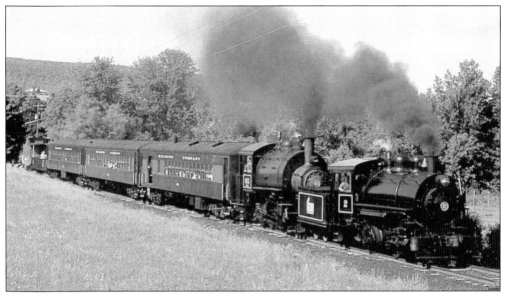

No. 2 and No. 65 depart Wanamaker for Kempton with a 30th-anniversary special on a scenic route through Berks and Lehigh Counties. No. 2 worked with Reading 0-4-0 camelback No. 4 at Birdsboro. No. 65 (0-6-0T 1930 Porter) was used in constructing Safe Harbor Dam. The first car (Combine 408) led many an Iron Horse Ramble. The trailing gondola with benches recalls Rail Rambles before and after World War II. And there is a red Reading caboose for good measure. (Courtesy the Wanamaker, Kempton & Southern Railroad.)

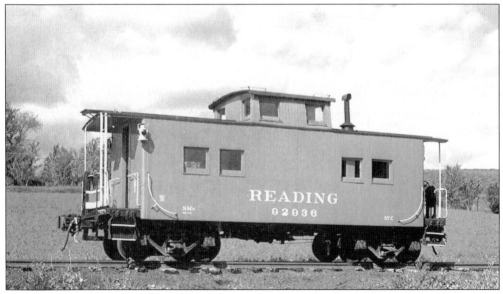

Reading caboose No. 92936 runs on the Wanamaker, Kempton & Southern and can be chartered. Reading Company Class NM-N, it was built of wood in September 1942 to conserve metal during World War II. It was rebuilt in March 1985 by the WK&S. A while back, a blue New Haven-Conrail caboose was placed in front of a McDonald's at Womelsdorf. Guided by this photograph, it was repainted red and relettered "READING," but with a different number: 92937. And so stories of Reading railroads continue. (Courtesy the Wanamaker, Kempton & Southern Railroad.)